T0364813

THE PERUVIAN FOUR-SELVAGED CLOTH

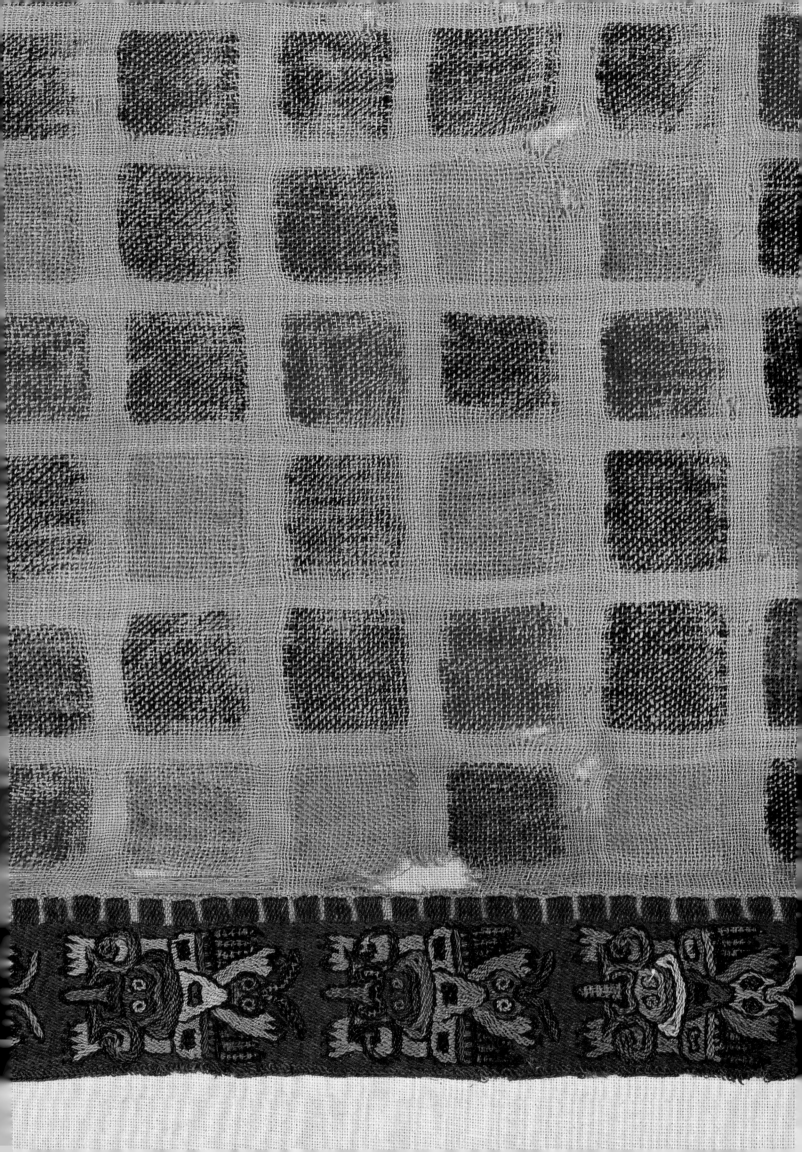

The Peruvian Four-Selvaged Cloth

ANCIENT THREADS ⚡ NEW DIRECTIONS

Elena Phipps

FOWLER MUSEUM AT UCLA *LOS ANGELES*

Fowler Museum Textile Series, No. 12

FOWLER
MUSEUM
Textile Series

This book has been funded by the Donald Cordry Memorial
Fund, the Shirley and Ralph Shapiro Director's Discretionary
Fund, and the R. L. Shep Endowment.

*This volume is published on the occasion of the fiftieth
anniversary of the Fowler Museum at UCLA.*

The Fowler Museum is part of UCLA's School of the Arts and Architecture
Lynne Kostman, *Managing Editor*
Gassian Armenian, *Editorial Assistant*
Danny Brauer, *Designer and Production Manager*
Don Cole, *Photographer*

Fowler Museum at UCLA
Box 951549
Los Angeles, California 90095-1549

Requests to reproduce material from this volume should be sent to the
Fowler Museum Publications Department at the above address.
Printed and bound in Hong Kong by Great Wall Printing Company, Ltd.
Library of Congress Cataloging-in-Publication Data

Phipps, Elena.
 The Peruvian four-selvaged cloth : ancient threads/new directions /
Elena Phipps.
 pages cm. — (Fowler Museum textile series ; No. 12)
 Includes bibliographical references and index.
 ISBN 978-0-9847550-5-9
1. Indian textile fabrics—Peru. 2. Fiberwork—History—20th century.
3. Fiberwork—History—21st century. I. Fowler Museum at UCLA. II. Title.
 F2230.1.T3P49 2013
 746.0985--dc23 2013021241

COVER: detail fig. 54; p. 1, fig. 65; p. 2, detail fig. 14; p.4, detail fig. 77; p. 64,
detail fig. 54; p. 65, detail fig. 67; p. 92, detail fig. 79; BACK COVER: detail fig. 90.

Contents

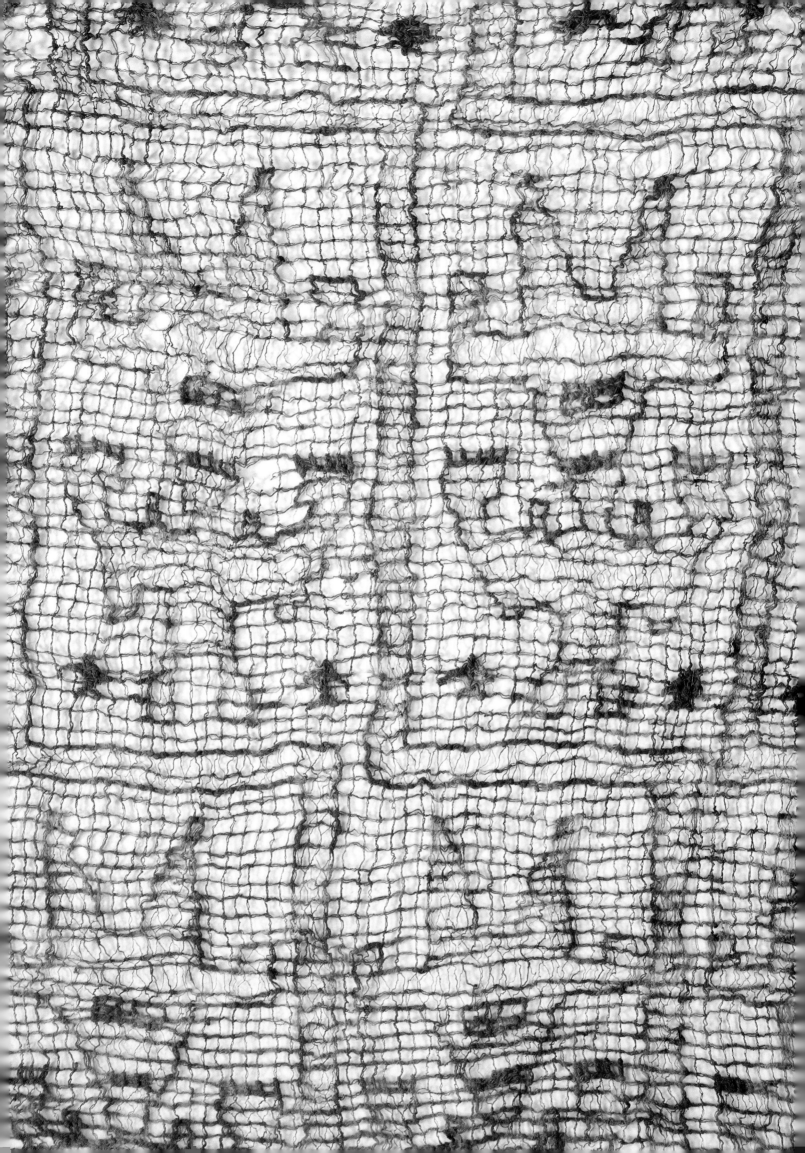

Foreword

The Fowler Museum is well known for its previous books and exhibitions dealing with the cultures of ancient Peru, produced under the leadership of former director Christopher Donnan, an archaeologist specializing in the region. *Ceramics of Ancient Peru* (1993) and *Moche Fineline Painting: Its Evolution and Its Artists* (1999) focused on the rich Peruvian ceramic traditions. *Royal Tombs of Sipan* (1993) detailed one of the most spectacular archaeological finds of the ancient Americas and became a major touring exhibition.

The prominence of these exhibitions at UCLA has, until now, rather overshadowed another category of ancient Peruvian art also well represented in the Museum's collections: handwoven textiles. Following the astonishing excavation in 1927 on southern Peru's Paracas Peninsula of 429 ancient mummies—wrapped in layer-upon-layer of elaborately woven cloth—textile scholars worldwide came to recognize that weavers in ancient Peru had created some of the most magnificent and complex handwoven textiles ever made. The techniques and the iconography are, moreover, exclusive to Peru, distinguishing the region as a unique center of ancient textile artistry. The Fowler Museum is fortunate to have two important collections of this material. The first came to the Museum as part of the Wellcome Collection in 1965. This was followed by a series of important gifts made by two of the Museum's most stalwart friends and patrons Mr. and Mrs. Herbert L. Lucas, Jr., between 1986 and 1991.

The Peruvian Four-Selvaged Cloth: Ancient Threads/New Directions is presented as one of eight exhibitions celebrating the Fowler Museum's fiftieth anniversary in the fall of 2013. What unites these exhibitions is that we have reached deeply into the Museum's collections to identify important sets of materials that have remained largely unknown to the public and have developed themes or avenues of approach that show the material in exciting and unexpected ways. We owe the stimulating concept for this particular project to guest curator Dr. Elena Phipps, who retired in 2010 from a thirty-three-year career as a conservator at the Metropolitan Museum of Art, where she was also one of the key planners of the Antonio Ratti Textile Center. Phipps currently serves as president of the Textile Society of America, and her previous scholarly publications include *The Colonial Andes: Tapestries and Silverwork, 1530–1830* (2004, co-authored with Johanna Hecht and Cristina Esteras), *Cochineal Red: The Art History of a Color* (2010), and *Looking at Textiles: A Guide to Technical Terms* (2011). She first gained familiarity with the Fowler's ancient Peruvian textiles in 2011 while teaching the art history of Andean textiles as a visiting professor through a course conducted in the Fowler's Center for the Study of Regional Dress.

Phipps saw an opportunity not only to probe the most central feature distinguishing ancient Andean weaving—the production of cloth with four finished selvages—but also to show how this unique way of looking at weaving continues to influence artists working today, more than two and a half millennia after ancient Peruvian weavers first conceived it. We are pleased to include in the exhibition contemporary works by renowned artists Sheila Hicks and James Bassler. Another featured artist, who developed an appreciation of four-selvage technology while working in Peru in the 1950s, is photographer, musician, and ethnomusicologist John Cohen. Phipps has included a selection of Cohen's beautiful photographs to capture the spirit of the cloth and the women who weave it. Taken together, these elements portray not just an unusual way of making cloth, but an entire way of thought that remains as captivating today as it was in the ceremonial life of ancient Peru.

We gratefully acknowledge the support of the Donald Cordry Memorial Fund, the Shirley and Ralph Shapiro Director's Discretionary Fund, and the R. L. Shep Endowment for the publication of this book. This volume, the twelfth in the Fowler Museum Textile Series, is the first to focus on a South American subject and is hopefully a harbinger of more to come reflecting that continent's rich textile traditions.

As with all of the Fowler Museum's projects, this exhibition and publication have drawn upon the energies, creativity, and professionalism of virtually every member of its staff, and I would like to express gratitude for this continued devotion to the Museum and its mission. (A full staff list appears at the end of this volume.) Danny Brauer designed and supervised the production of this handsome book, Don Cole photographed the Fowler textiles, and Lynne Kostman edited it with assistance in the area of rights and reproductions from Gassia Armenian—all performing with their usual talent and efficiency. It is our sincere hope that this book and the exhibition accompanying it will stimulate further scholarship and inquiry into the meaning of the four-selvaged cloth, as well as prove provocative and engaging to our audiences.

Roy W. Hamilton
SENIOR CURATOR OF ASIAN AND PACIFIC COLLECTIONS

Detail of figure 15.

Acknowledgments

I have long wanted to write about the four-selvaged cloth in Andean culture. Complex in its process and extensive in its range within South America, it is a phenomenon that has sparked the imagination of scholars and artists alike. This is despite the fact that the full significance of these textiles with four finished edges within their original cultural context is still not fully understood. I am profoundly grateful to Marla C. Berns, the director of the Fowler Museum at UCLA, for providing me the opportunity to explore this subject through the Museum's wonderful collection of Peruvian textiles. Forged over fifty years, the Fowler collection contains works of astonishing beauty and historical importance as well as humble fragments—all of which retain their cultural significance and contribute to our knowledge of ancient Peru.

I am also deeply indebted to contemporary artists James Bassler, John Cohen, and Sheila Hicks who have agreed to engage in the dialogue I have proposed between ancient and modern weaving cultures by lending their works to the exhibition and sharing their ideas, their histories, and their personal views on the subject with me. I am so happy to have the chance to bring them together for the first time, and I must express my appreciation once again to Marla Berns, this time for her openness to and encouragement of new directions in textile exhibitions.

The gathering of works from a variety of collections and locales has been greatly aided by many people. Katie Rashid of Sikkima-Jenkins Co., New York, Gail Martin of Martin Gallery, New York, Parker Stephenson of L. Parker Stephenson Photographs, New York, and Alison Jacques, of Alison Jacques Gallery, London, all lent their support to the enormous task of gathering, documenting, and securing the works for exhibition, generously demonstrating the symbiotic relationships that can exist between artists and their dealers. Matilda McQuaid, Cara McCarty, and Lucy Commoner of the Cooper-Hewitt National Design Museum, Smithsonian Institution, New York, were extremely supportive of this project, not only lending their wonderful objects but providing good will and friendship as well. Private lenders in New York and Los Angeles also graciously agreed to part with their treasures for a time and allow them to be displayed in this exhibition, and I thank them sincerely.

In 2011 Patricia Anawalt, the director of the Center for the Study of Regional Dress at the Fowler Museum, invited me to teach a class on the textiles of Peru during the fall quarter. This gave me the opportunity to examine closely many of the Andean textiles in the Fowler collection, and it opened my eyes to some of its treasures. Barbara Belle Sloan, the associate director of the Center, facilitated my study offering her constant help and guidance through the maze of storerooms, cabinets, drawers, and boxes that have helped preserve these textiles. The Center has played an important role in utilizing the Fowler textile collection as a key resource for teaching, and as a result, it has stimulated the interest in textiles broadly and diversely, not only within the UCLA community but beyond. I am very grateful to Patty for her vision in establishing the Center and to Barbara for her stewardship of its work and activities. I would also like to thank former Fowler director Christopher Donnan for lending his expertise in the area of Peruvian ceramics as well as his knowledge of the Fowler's Peruvian textile collection. His timely suggestions for selected works enabled the wonderful cotton panel with designs of corn stalks to be included—one that had previously been overlooked.

Over the years, the Fowler's Peruvian textile collection had been documented meticulously by Mary Jane Leland and Nancy Porter, whose expertise in the area of textile identification and cultural attribution provided the groundwork for the Museum's cataloging, and hence for this publication. The Museum has also retained the notes of others who have examined the textiles over the years, creating an invaluable record of the input of the important scholars from around the world who have not only visited but contributed to the documentation of the textiles, their construction, technique, and origin. In addition to the scholars who have amplified upon the Fowler's records, I would also like to thank colleagues, especially Sophie Desrosiers, Ann Rowe, and Amy Oakland for years of fruitful discussions on Andean textiles. Their insightful comments and deep commitment to textile research have greatly contributed to the basis of our current knowledge of the subject.

Finally, my sincere thanks are due to Roy W. Hamilton, the Fowler's senior curator of Asian and Pacific collections, who has ardently supported this project from its very inception through to its completion. I thank Roy for all of his help and advocacy on behalf of the endeavor and for his critical eye and professional contributions to the publication and the accompanying exhibition. I would also like to join him in thanking the entire Fowler Museum staff for its remarkable and professional efforts in making this project a reality.

Elena Phipps

Detail of figure 75.

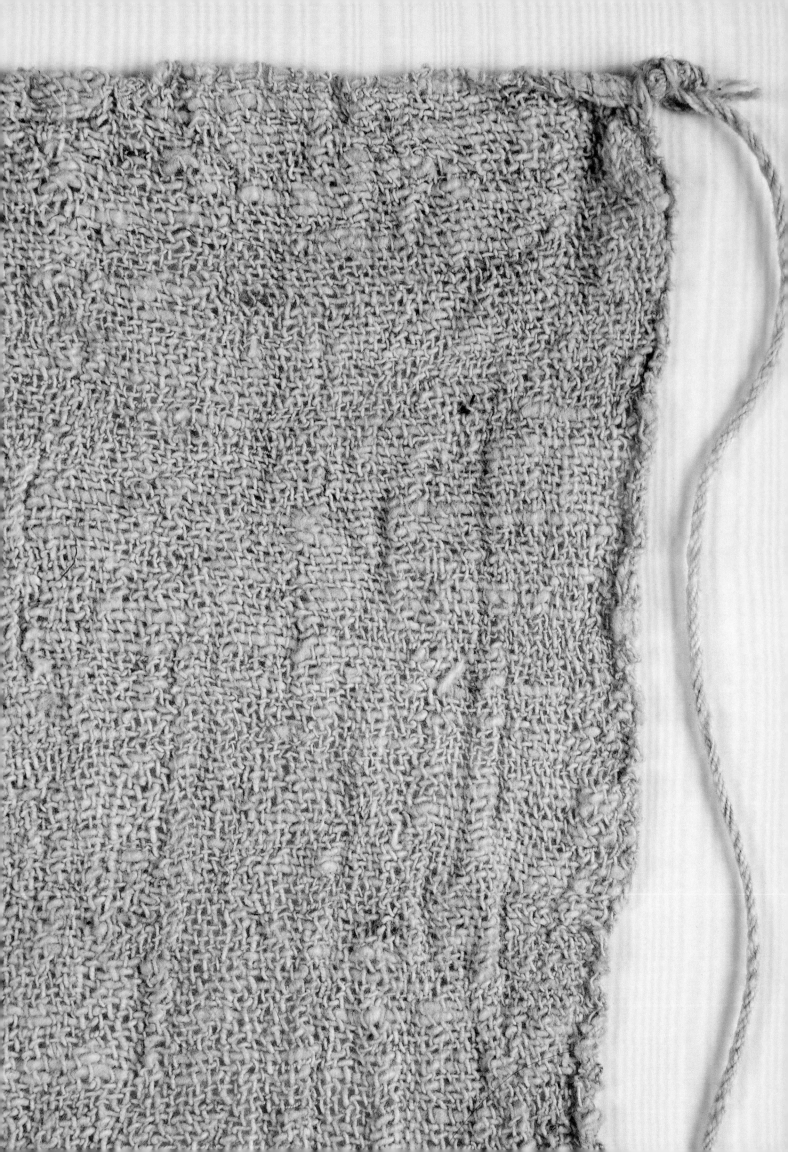

PART ONE The Peruvian Four-Selvaged Cloth

Every piece of cloth they made, for whatever purpose,
was made with four selvages. Cloth was never woven
longer than what was needed for a single blanket or tunic.
Each garment was not cut, but made with a piece as the
cloth came from the loom and before weaving it they fixed
its approximate breadth and length.

GARCILASO DE LA VEGA (1609)

A textile with four complete, uncut woven edges (selvages) is a
rare thing. The four woven edges indicate that the weaver knew
exactly what she wanted to make before she began weaving. By
carefully conceiving and planning her project, she could create
it directly on the loom in its final form, woven to the specific
size and shape intended. Apart from Peru, only a few places in
the world produce such textiles today; they are occasionally made
in Mexico, for example. In the Andes, however, the four-selvaged
cloth has an extremely long heritage, and it is the norm rather
than the exception.

The extraordinary nature of this weaving process was
remarked upon by Garcilaso de la Vega (1539–1616) in his
Comentarios reales de los Incas (Royal commentaries of the Inca),
published in Lisbon in 1609.[1] Known as "El Inca," Garcilaso,
whose father was a Spaniard and mother an Inca noblewoman,
was a famous Peruvian scholar of Inca culture, born just seven
years after the conquest of Cuzco, the Inca capital. The present
volume follows in Garcilaso's footsteps, exploring the meanings
and manifestations of this special act of weaving in the ancient
pre-Columbian cultures of the Andes. It also examines how the
significance of the four-selvaged cloth resonates strongly within
the creative processes of three contemporary artists.

TEXTILE TRADITIONS IN THE ANDES

The Andes is a term used generally to define the swath of
South America extending from the desert coast (fig. 1) to the
peaks of the Andes mountains and beyond to the high-altitude
plains known as the altiplano. The Andes range, among the
highest in the world, runs north and south from Columbia to
Chile, encompassing present-day Columbia, Ecuador, Peru,
Bolivia, and parts of Argentina and Chile. The diverse cultures
that thrived in the harsh and contrasting climate zones of this
region developed rich and varied textile traditions utilizing
natural materials available within local ecosystems.

The coast, especially in Peru and Chile, is characterized by
extreme landscapes consisting of arid deserts alternating with
fertile river deltas, which are watered by snowmelt flowing from
the high peaks of the mountains down to the sea (fig. 2). The
coastal region was an important area for cultural development
and the site of some of the first locations in South America
where evidence has been found of domestic societies extending
back millennia. Early fishing cultures developed along the coast
and used cotton and fibers from various reeds or plants such as
maguey (*Furcraea* sp.) to construct knotted fishing nets, looped
and twined bags, as well as other utilitarian items (fig. 3). These

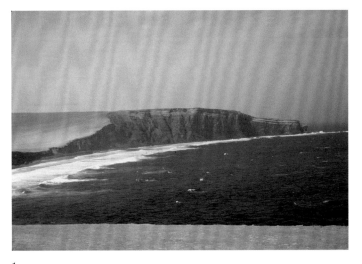

1
The Paracas Peninsula, located along the arid south coast of present-day
Peru, is the site of the spectacular archaeological excavations of the 1920s
that revealed over four hundred elaborate burials and hundreds of textiles.
PHOTOGRAPH BY ELENA PHIPPS, 1980.

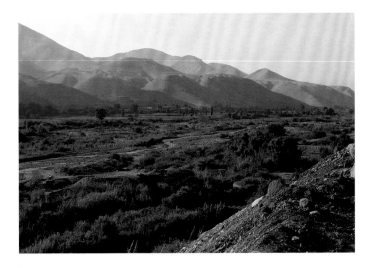

2
The fertile delta of the Ilo Valley sharply contrasts with the adjacent desert.
PHOTOGRAPH BY ELENA PHIPPS, 2005.

OPPOSITE: Detail of figure 17.

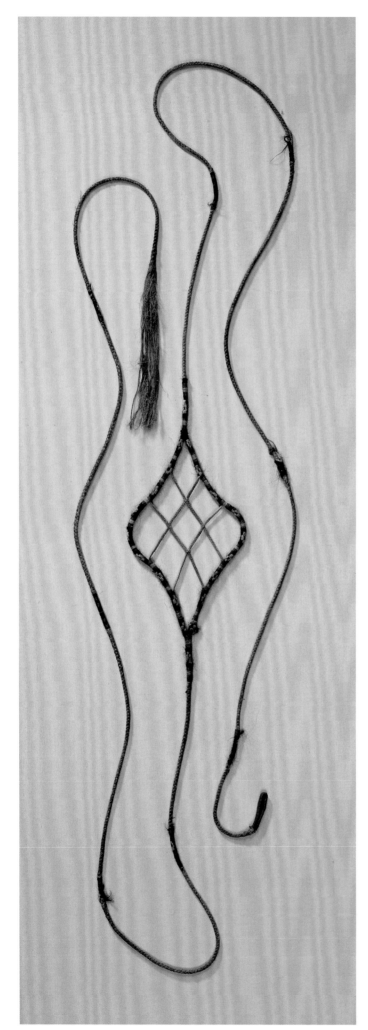

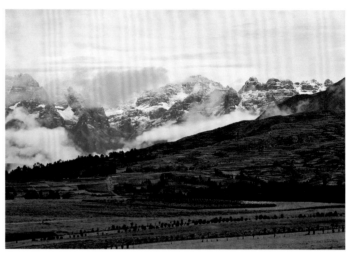

4

This view was taken outside of Chinchero on the road to Urubamba in the highlands of Peru. PHOTOGRAPH BY YUTAKA YOSHII, 2011.

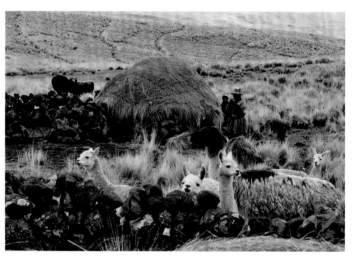

5

Llamas rest in a highland corral. PHOTOGRAPH BY YUTAKA YOSHII, NEAR ESPINAR, PERU, 2011.

3
Sling for hunting birds (?)
Inca culture, unknown provenance
Inca Period (?), 1438–1532
Plant fiber, dyed camelid hair; braided and wrapped
224 x 9 cm
FOWLER MUSEUM X90.697; GIFT OF DORAN H. ROSS
NOT IN EXHIBITION

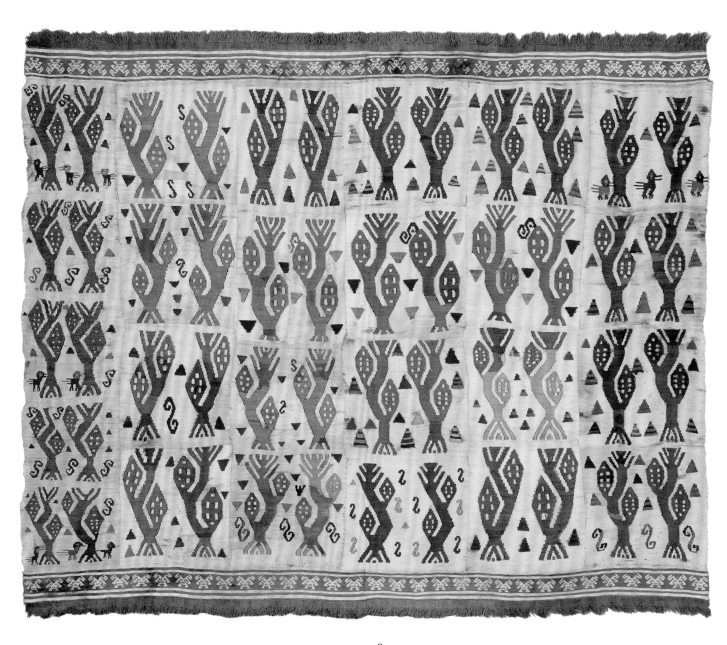

textile practices formed a matrix of knowledge and a foundation for cultures that developed this art form even prior to the making of ceramics, which is often considered the first mark of civilization.

The colder, high-altitude portions of the Andes may also have been a site of early developments in textile production, but few examples have been preserved for study today. The mid-level valleys of this region contained fertile soils terraced to maximize the yield of corn and other grains that sustained populations (figs. 4, 6), along with the many types of potatoes that grew in high altitude plains. These valleys also provided seasonal grasses for grazing animals of the camelid family—llamas (fig. 5), alpacas, vicuñas, and wild guanaco. These animals provided the primary means for transport of goods throughout the mountainous region and were also the source of the prized silky hair used to make warm garments for protection against the cold and to produce some of the finest cloth made anywhere in the world.

6
Panel or tunic with corn plants
Possibly Chimu culture, Ica Valley, south coast of Peru (?)
Late Intermediate Period, 1150–1450 CE
Cotton warp, cotton and camelid hair weft; tapestry weave
95 x 114 cm
FOWLER MUSEUM X94.27.6; GIFT OF NEUTROGENA CORPORATION

Six four-selvaged panels are stitched together.

Corn, or maize (*Zea mays*), has been found in archaeological contexts for thousands of years, and it was fundamental to sustaining Andean civilization. It was also used to make beer, an essential component of all ritual celebrations held to insure the fertility of seeds and crops for harvest. This cloth, composed of six separately woven panels bearing images of corn plants was likely used during such ritual celebrations.

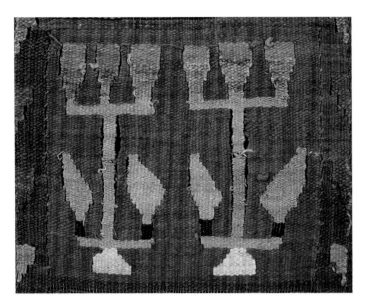

7
Detail showing a cotton plant motif woven into center panel of a tunic
Moche culture, Pacatnamu, Jequetepeque Valley, north coast of Peru
500–700 CE
Resist-dyed cotton, camelid hair; plain weave with cotton warp,
camelid-hair-weft tapestry panels
FOWLER MUSEUM X86.3956; GIFT OF MR. AND MRS. HERBERT L. LUCAS, JR.
NOT IN EXHIBITION

Whether using cotton (fig. 7) or camelid hair, Andean weavers achieved incredibly complex technical feats, interlacing colored yarns to form a great variety of designs. The textiles they produced are not only remarkable for their beauty and technical achievement, however; they also represent a wealth of knowledge and creativity, and they have served as a primary means of cultural expression from at least the third millennium BCE to the present day. Textiles and textile techniques, in addition to being used for garments, have also figured in the development of mathematical models and the creation of tools (see fig. 3), weapons, architecture, and bridges, among many other functions. Furthermore, in some cases early cultures used textiles as an important means of communicating religious ideas. Painted with earthen minerals—ocher, hematite, and vermillion—such special cotton cloths portray deities and ritual activities that were of vital importance to communities that had no written language. Unlike monumental stone sculptures in temples, sacred precincts, and pilgrimage centers—whose iconographic programs are also found in their woven counterparts—textiles could travel easily, and their portability contributed to the spread of early religions (figs. 8a,b, 9).[2]

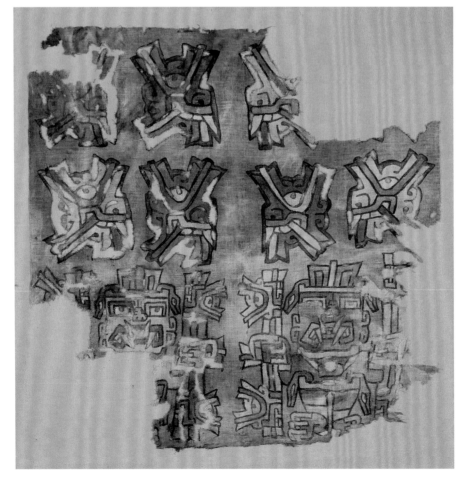

8A
Ceremonial textile fragment
Chavin culture, likely Carhua,
Ica Valley, south coast of Peru
Early Horizon, circa 500–300 BCE
Cotton warp and weft; plain weave
painted with tannin dyes and earth
pigments
65 x 63 cm
FOWLER MUSEUM X86.2929; GIFT OF
MR. AND MRS. HERBERT L. LUCAS, JR.

*Remnants of the warp and weft
selvages are preserved.*

The staff-bearing, cross-fanged standing deity figures (see fig. 8b), wearing double-headed snake headdresses and belts, derive from the religious iconography and style carved into the stone monuments of the powerful ceremonial site of Chavín de Huántar in the mountain area of northern Peru. Found thousands of kilometers away, this cloth provides evidence of its own history. Its design is from the north highlands; its technical details, including the telltale spin direction of the single and plied yarns may be from the central coast; while it was found buried in the south.

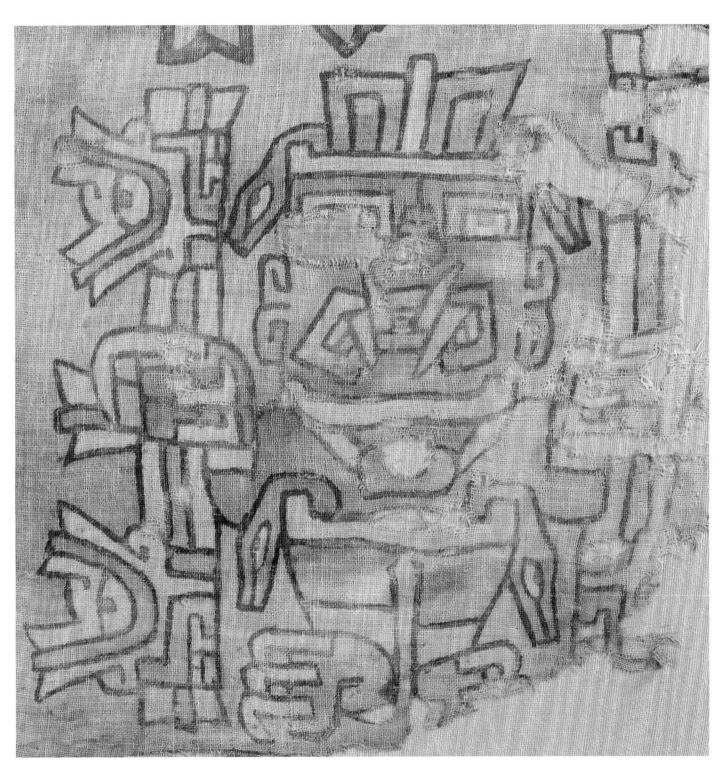

8B
Detail of figure 8a.

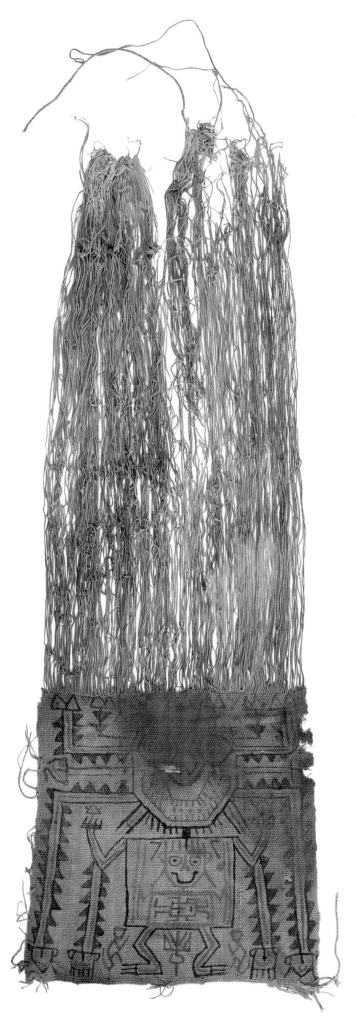

The ability to create complex representations on cloth was greatly enhanced when highland animal fibers became available on the coast sometime around the fifth to the third century BCE, as they could be dyed with a wide array of colors. (Cotton, as a cellulosic material, is less able to absorb and permanently bond with dyes, while the proteinaceous animal fibers were highly compatible with most color sources.) Using only natural materials, dyers created hundreds of different colors, and the increased availability of colored yarns spurred the development of woven, as opposed to painted, designs (fig. 10a,b).

Both plant and animal dyes were found in abundance in the Andes. Blues came from indigo—a coloring substance found in the leaves of a number of tropical and semitropical plants. Reds came from two main sources. One was the roots of plants in the genus *Relbunium*, which belongs to the same Rubiacea family as European madder and was used to produce an orangish red (fig. 12). The other was a small insect called cochineal (*Dactylopius coccus*), which lives on cactus and produces a brilliant pinkish red that was highly prized (fig. 11). Yellows came from a wide variety of plants—flowers, leaves, and barks—and browns from seedpods and trees. Oranges derived from seeds of annatto pods (*Bixa orellana*), and purples from the glands of a shellfish that lived along the rocky coast, as well as the heartwood of tropical trees, including brazilwood (usually *Caesalpinia echinata*) and logwood (*Haematoxylum campechianum*). The availability of these rich dye colors spurred technical experimentation, resulting in an explosion of creativity in the textile arts.

9
Burial face mask
Paracas culture, Ocucaje, Ica Valley, south coast of Peru
Early Horizon, circa 400–300 BCE
Cotton warp and weft; plain weave with unwoven warps, painted tannin dyes
77 x 30 cm
FOWLER MUSEUM X2005.1.1; GIFT OF MR. AND MRS. HERBERT L. LUCAS, JR.

Three woven selvages plus original uncut warp loops along fourth edge make this face mask complete.

Funerary masks have been found in burials from the Ica Valley, placed on the outside of mummy bundles. Most have designs of faces or figures drawn on the surface of cotton cloths. The figure depicted here has large eyes and a grinning mouth; it also has a smaller figure contained within its body (similar to that depicted in the Cavernas double-cloth textile; see figs. 10a,b), an image that may relate to the concept of regeneration and the afterlife.

This textile is complete with all four selvage edges preserved even though the long lengths (warp yarns) may not seem finished. These were intentionally left unwoven so that they could be wound together and tied as a topknot for this dye-painted burial mask.

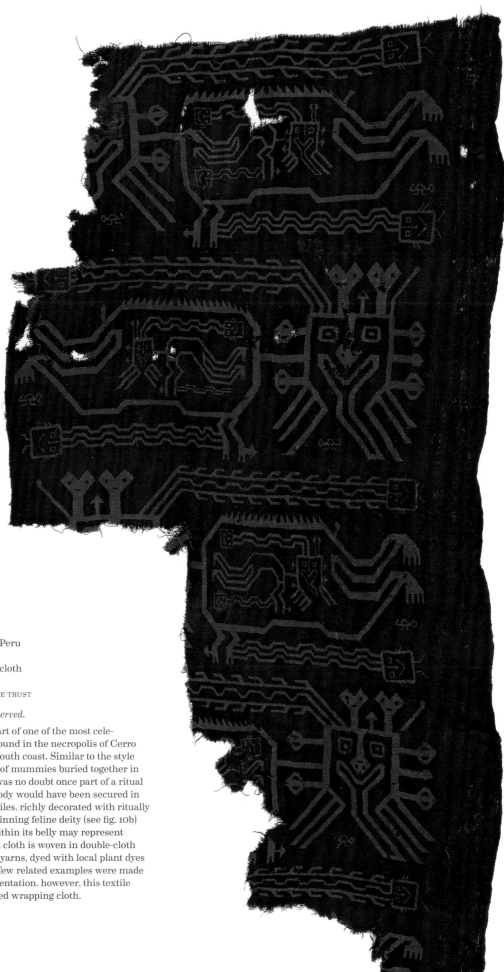

10A
Fragment of ceremonial mantle
Paracas Culture (Cavernas), south coast of Peru
Early Horizon, circa 400–300 BCE
Camelid-hair warp and weft, dyed; double-cloth
148 x 74 cm
FOWLER MUSEUM X67.526; GIFT OF THE WELLCOME TRUST

Remnants of three of the four selvages are preserved.

This fragment of a ceremonial mantle is part of one of the most cele-
brated groups of early textiles from Peru, found in the necropolis of Cerro
Colorado on the Paracas Peninsula of the south coast. Similar to the style
associated with the Cavernas group—a set of mummies buried together in
bottle-shaped deep tombs—this fragment was no doubt once part of a ritual
burial of an important individual, whose body would have been secured in
layer-upon-layer of resplendent woven textiles, richly decorated with ritually
significant imagery for the afterlife. The grinning feline deity (see fig. 10b)
with a miniature version of itself nested within its belly may represent
regeneration and fertility. This two-colored cloth is woven in double-cloth
(two layers), from finely spun camelid hair yarns, dyed with local plant dyes
likely from *Relbunium* roots (see fig. 12). A few related examples were made
as tunics. Because of its size and design orientation, however, this textile
may have been created especially as a sacred wrapping cloth.

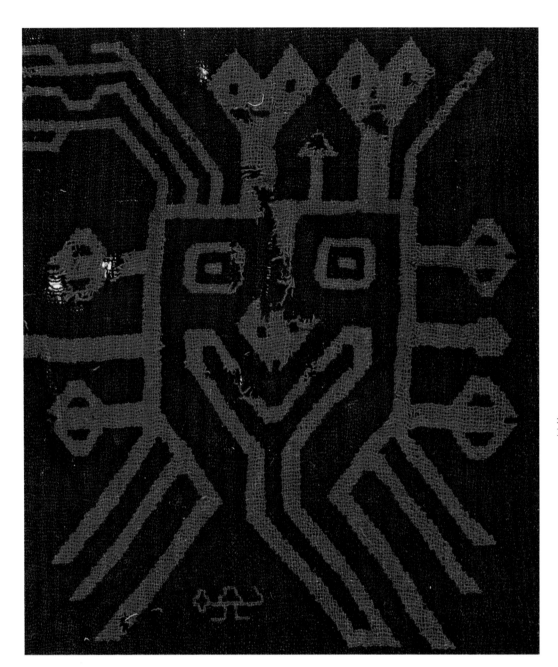

10B
Detail of figure 10a.

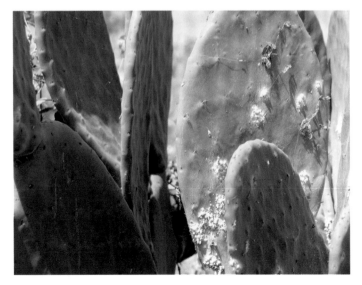

11
Cochineal is a scale insect that lives on prickly-pear cacti (genus *Opuntia*). The female produces carminic acid, the source of the red dye. Laying her eggs, she coats herself with a white sticky substance as a protective cover. Nested between the spines of the cactus, the insects are harvested carefully, usually with fine brushes. PHOTOGRAPH BY ELENA PHIPPS, NASCA VALLEY, 2008.

12
The fine roots of plants in the genus *Relbunium* were used as a dye producing an orangish red color. PHOTOGRAPH BY A. ROQUERO, SOUTHERN PERU, 1970S.

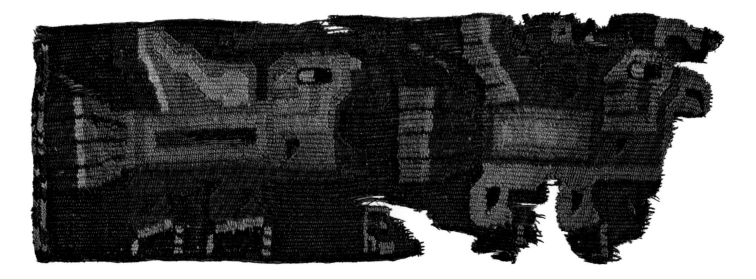

TECHNIQUES AND CULTURAL TRADITIONS

Working with fingers, needles, heddles, and looms, textile artists built a technical vocabulary that included knotting, looping, braiding, twining, weaving, and embroidery and created a common basis for Andean textile art. Successive cultures, however, developed and adapted signature weaving traditions that encapsulated their specific heritages and their territorial, political, and religious identities, representing them in the creation of artworks that integrate materials, techniques, iconography, and meaning. Different traditions of weaving developed between the highland cultures and the coast, and also from north to south.

Methods of producing tapestry weave are a case in point. Although this weaving method is used throughout the Andes, the ways in which transitions are effected from one area of color to another vary between highland and coast. The style of interlocking tapestry weaving that developed from about 600 to 1000 CE, when the Wari and Tiwanaku highland cultures dominated much of the southern region of Peru, represents one technique, and it was used to produce tightly woven pictorial images in garments that were part of a cultural expression of power and identity. The tapestry band with bird design shown in figure 13 is an example of the early development of this iconic style.

Cloths from the north coast cultures of Moche (100–800 CE), however, show a different style of tapestry weaving, using open slits between color areas, which are also formed in blocks, rather than interlocking each colored weft yarn, as the Wari did. Creative ways of weaving color, leaving regular openings between areas, gave the cloth added texture and design elements (see figs. 48a,b). This creativity was very apparent in the southern coast, from the Paracas Peninsula to the Nasca Valley, where spectacular examples of textile design and production were generated (figs. 14a,b). Notably from 300 BCE to around 500 or 600 CE, highly skilled artisans worked to produce sets of textiles that defy description in their intricacy and their detailed work, especially those embroidered with needles and brilliantly dyed yarns; these were intended for use in burials. Creating three-dimensional bird figures from loops of yarns (see fig. 50) or flying creatures that are part-human and part-feline, south coast weavers and needleworkers displayed a range of imagination equal to their remarkable skills.

13
Fragment of a band with bird design
Early Tiwanaku style, south coast of Peru
Early Intermediate Period, 200–400 CE
Camelid-hair warp and weft; tapestry weave, interlocking joins with chain-looped embroidery
24 x 8 cm
FOWLER MUSEUM X86.2913; GIFT OF MR. AND MRS. HERBERT L. LUCAS, JR.

Three of the four selvages have been preserved.

Tiwanaku culture extended from the Lake Titicaca highlands to the south coastal region of Peru. Images of birds were among its primary icons of power—often shown attending a staff-holding deity figure well known from the stone monument called the Gateway of the Sun. In this tapestry fragment, possibly part of a headband, the bird stands in profile. It has a powerful crooked beak, massive legs, markings around the eyes, tricolored tail feathers, and an elaborate feather on top of its head. One end of this fragment is complete with rows of chain-looped embroidery.

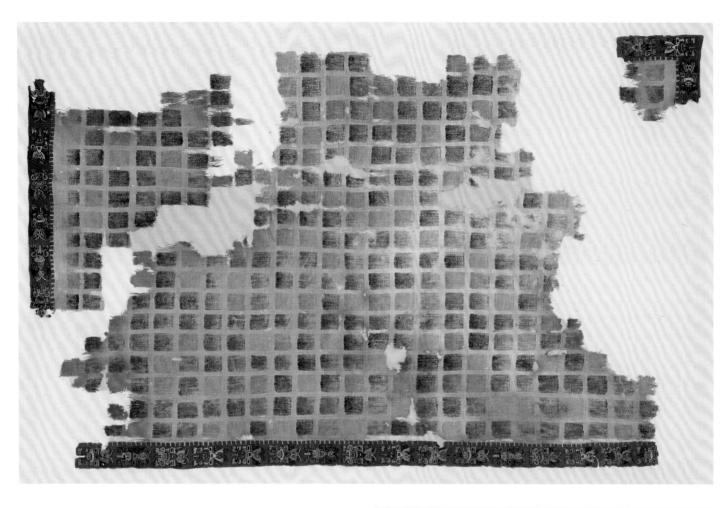

14A,B
Fragment of a ceremonial textile
Nasca culture, south coast of Peru
Early Intermediate Period, circa 100–300 CE
Cotton warp and weft, dyed camelid hair, added fiber and embroidery;
central panel: plain weave with warp wrapping; edges: plain-weave woven
bands with stem-stitch embroidery
72 x 45 cm
FOWLER MUSEUM X86.2925 (INCLUDING 2914–2918 FRAGMENTS);
GIFT OF MR. AND MRS. HERBERT L. LUCAS, JR.

*Preserved parts of all four selvages from central panel are present; side selvages
are present on embroidered bands.*

This extraordinary ceremonial textile is one of only three known examples
made utilizing a special technique for creating this visually simple, yet techni-
cally complex, design of colored squares (see fig. 85). The weaver used unspun
dyed fibers that are wrapped around the warps during the weaving process to
create the color blocks. The unusual design simplicity of the color blocks and
their non-repeating sequence contrasts with the embroidered bands, which
feature flying four-legged creatures who have feline whiskers and snake-head
tails (see fig. 14b). The small size of this textile, in relation to others from the
period, may indicate that it was once part of a set of ritual paraphernalia and
used to create a sacred space, such as for an altar or ritual mesa.

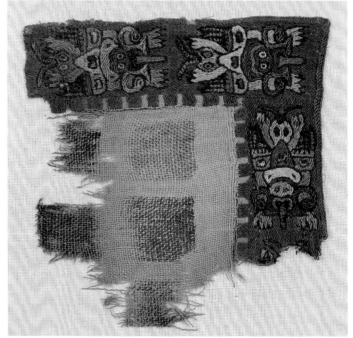

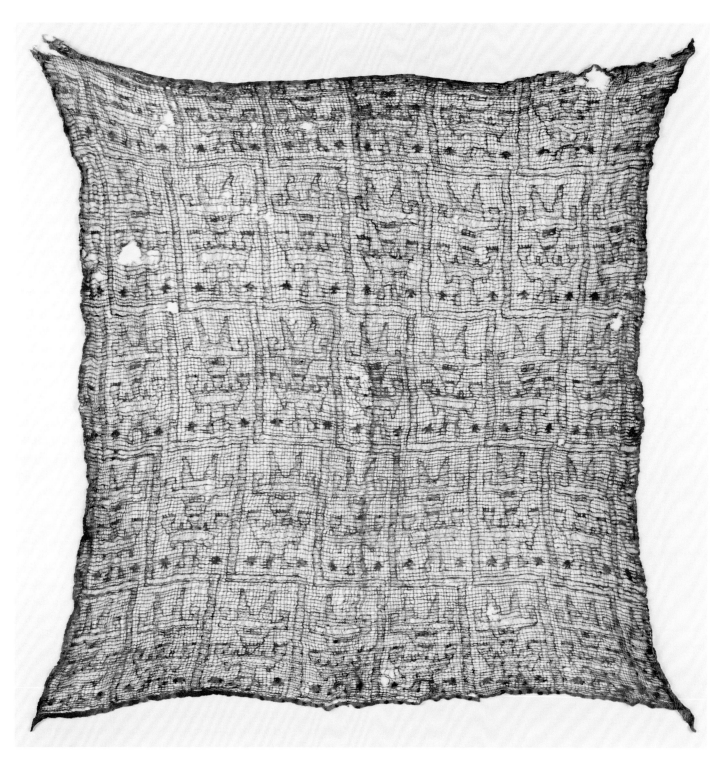

15
Panel with crowned figure
Chancay culture, central coast of Peru
Late Intermediate Period, 1150–1450 CE
Cotton warp and weft with yellow and orange pigments and a possible
shellfish purple dye; gauze patterned with weft wrapping and knotting
94 x 93 cm
FOWLER MUSEUM X65.7603; GIFT OF THE MAY COMPANY DEPARTMENT STORES

Two four-selvaged panels are seamed in the middle. All selvages are preserved.

This sheer and flexible textile, created using the complex technique of
patterned gauze weave with knotting, may have served as a ceremonial
wrapping cloth. A figure is depicted within the sheer cloth, repeated
horizontally and vertically, inscribed within a stepped enclosure
(see p. 6). He wears a short tunic and a pointed and elongated crown
and has upturned five-fingered hands or paws.

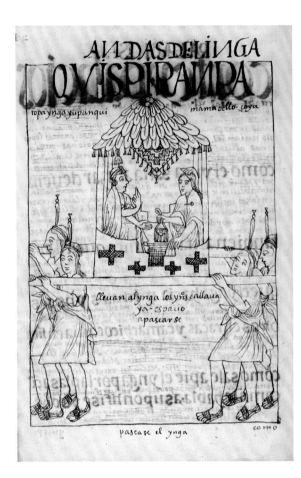

16

This early seventeenth-century illustration shows the Inca king carried in a palanquin. When traveling, he changed his clothing to conform to locale customs. REPRODUCED FROM GUAMAN POMA DE AYALA, NUEVA CORÓNICA Y BUEN GOBIERNO, 1614, FOL. 333, UNPUBLISHED. COURTESY OF THE ROYAL LIBRARY, DENMARK.

Centuries later, on the central coast in the region of the Chancay Valley, weavers produced lightweight masterpieces of gauze and knotting, spinning hair-thin yarns that cross and bind to create intricate designs. This technique required adaptations to the loom in order to transpose the warp yarns and may be a faint remnant of ancient methods that subsequently became fully articulated during the fluorescence of the region from the twelfth to the fifteenth century. These sheer textiles often contain geometric or bird designs and can be produced with simple or more complex variations in technique. The example illustrated in figure 15, shows a standing figure with headdress or crown. It is made in a combination of gauze and knotting, and has unusual applied color on its surface.

Origin myths chronicled in the early seventeenth century by Joan de Santa Cruz Pachacuti Yamqui Salcamaygua, a Peruvian writer from the region of Cuzco, provide an explanation of how the diversity of textile traditions came to be in the Andes. The Inca, for example—whose empire extended from Ecuador to Chile during the end of the fifteenth and beginning of the sixteenth centuries, at the dawn of the Spanish arrival—indicated that when the world was made, the mythological founder of the Inca people, Manco Capac, decreed that each area should have its own way of dress and its own language.[3] We know from other documented Inca histories, that the Inca king acknowledged the importance of this tradition, as during his travels throughout the empire, he was said to have changed his garments to conform to those of each region, donning the tunic of the local style, as he crossed cultural boundaries (fig. 16).

For the Inca, garments were key to a whole set of social and political relations, and weaving on behalf of the king was mandated for all households (see fig. 51). In addition, specialized weavers (*acclas*) were selected from throughout the empire and housed together in special facilities called *acclawasi*. *Acclas* were young women, chosen to be trained in the arts of spinning yarn and weaving in order to produce the highly refined and luxurious tunics worn by the king and the nobility or given as gifts of diplomacy in exchange for fealty in times of war. The other major task performed at these weaving enclaves was the production of maize beer used for all ritual and celebratory events.

Early sixteenth-century eyewitness accounts concerning the Inca are preserved. As no written language existed prior to the coming of the Spanish, however, the only evidence we have about the cultures that preceded the Inca comes from archaeological remains. Villages, towns, and administrative centers, along with important religious sites have been uncovered, and the rich legacy of the Andean textile traditions has been preserved in the tens if not hundreds of thousands of textiles that have been found. Ritual burials and refuse middens located primarily in the dry coastal desert have preserved evidence— sometimes in astonishing condition—of the incredible weaving of the region. Textiles lying beneath the sandy surface were protected from the sun and water for possibly thousands of years. While the diversity of textiles, region to region and time period to time period throughout the Andes is extensive, certain underlying principles remained constant regardless of locale or era. One of these is the concept of a four-selvaged cloth.

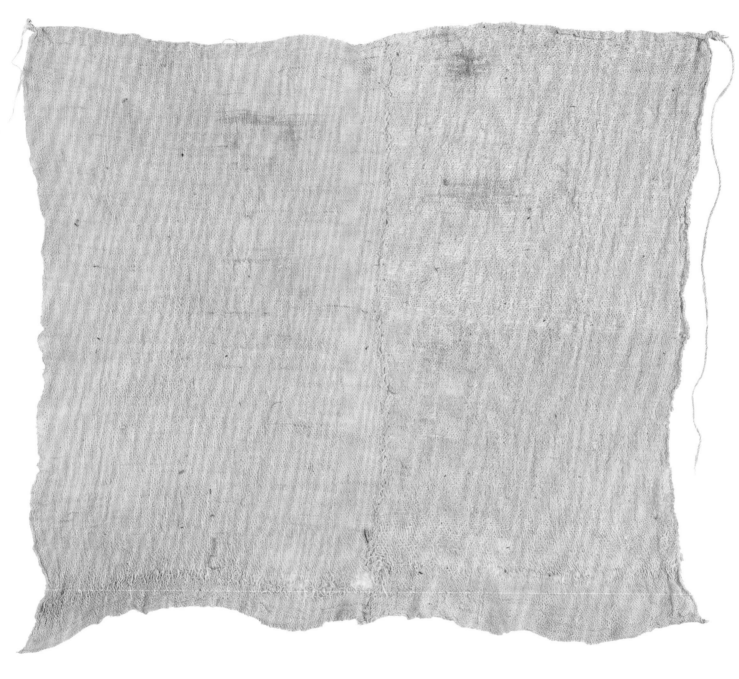

17
Shawl or wrapping cloth
Chancay culture, central coast of Peru
Late Intermediate Period, 1150–1450 CE
Cotton warp and weft: plain weave
48 x 58 cm
FOWLER MUSEUM X72.544; GIFT OF LEO DRIMMER

Each of the two panels has all four selvages preserved.

This four-selvaged cloth retains its long loom cords. Two panels of finished cloth have been stitched up the middle to create this shawl or wrapping cloth. The overspun yarns used in the weaving are kinked (see fig. 26), and when pulled, they stretch creating flexibility in the cloth, so that it could be snugly wrapped around the shoulders of a woman or used to secure a baby or bulk of harvested corn to her back.

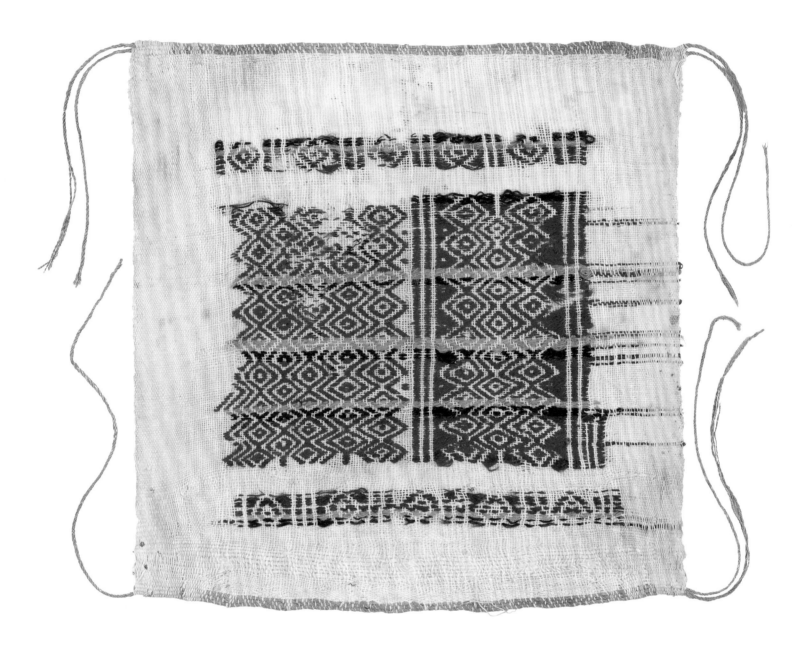

18
Weaving practice sampler
Coastal Wari culture, south coast of Peru
Middle Horizon, 600–1000 CE
Cotton warp and weft and dyed camelid-hair weft; plain weave with
supplementary-weft float patterning
24 x 23 cm
FOWLER MUSEUM X65.8791; GIFT OF THE WELLCOME TRUST

Four selvages are preserved, as well as loom cords.

This small four-selvaged cloth was made as a practice piece or sampler
by a weaver learning to create geometric designs in positive and negative
versions. Created row by row with supplementary, dyed camelid-hair yarns,
the diamond pattern on the left side is made with red lines against a white
background, while that on the right side is made with white lines against
a red background. Having gained expertise with this sampler, the weaver
could then apply this skill to creating the Wari-style square panels with
decorated corners (see fig. 40).

THE MAKING OF A FOUR-SELVAGED CLOTH

As noted earlier, the weaver of a cloth with four uncut edges knew exactly what she was going to make and the size it would be before beginning her project—whether it was a bag to carry coca leaves used to "calm the blood" at high altitudes, a mantle to cover the shoulders of woman, a rectangular cloth to carry potatoes from the field, the garment of a king, clothing for the statue of a sacred deity, or a burial cloth for an honored ancestor. This type of weaving respects the integrity of the cloth as a whole, and it is deeply embedded within a whole set of values that are interrelated with both the physical and metaphysical realms of artistic production (figs. 17, 18, and see figs. 14a,b).

Fibers and Spinning

Weaving begins with fiber production—the gathering, cleaning, preparing, and spinning of yarns. In the Andes, two primary fibers were used: cotton and camelid hair. Cotton was cultivated along the coast and grew in several natural colors (fig. 19), including white, cream, brown, pinkish, and even greenish gray (see figs. 61a,b). It was spun on thin spindles and small round spindle whorls into fine single threads that could then be used as is or plied together to form a stronger yarn (figs. 20, 21a-c). Camelid hairs came in a variety of qualities and a number of natural colors (figs. 22–24).

The spinning of fibers results in a directional twist. Various cultures developed traditions of spinning in particular ways—whether to the right or left, with the spindle placed in a horizontal or vertical orientation, in a supported or dropped motion. This directionality can be seen in the resulting yarns, conventionally described as an S-spun or a Z-spun yarn. (S and Z are conventions to visualize the direction of spin—by superimposing the letter onto the yarn when placed in a vertical orientation; fig. 25). Adding additional twist to the yarn—sometimes described as overspun yarn—can cause the yarn to double over on itself. This characteristic was intentionally applied to certain yarns used in fabrics where flexibility and the capacity to stretch were desired (fig. 26).

To strengthen the yarns for weaving, many Andean cultures plied them—bringing together two or more twisted strands and re-twisting them in the opposite direction (figs. 27, 28). Some did not ply, instead using two single yarns together for weaving. Many combinations were possible, and consistencies among cultural and regional groups can be seen as part of the overall "fingerprint" of local weaving traditions.

19
Long-stapled native Peruvian cotton (*Gossypium barbadense*) is a fine fiber with a silky quality. PHOTOGRAPH BY ELENA PHIPPS, ICA VALLEY, PERU, 2008.

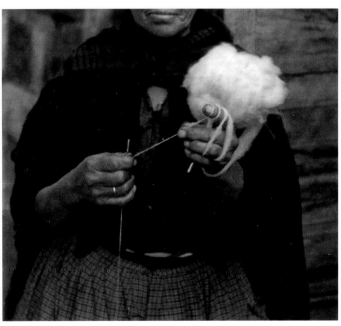

20
John Cohen (b. New York, New York, 1932)
"Spinning with distaff, now used in Huaycayo but no longer in Cuzco"
Mid-1950s
Black and white photograph
COPYRIGHT JOHN COHEN, REPRODUCED WITH PERMISSION FROM *PAST PRESENT PERU: ANDEAN TEXTILES* (STEIDL, 2010)
NOT IN EXHIBITION

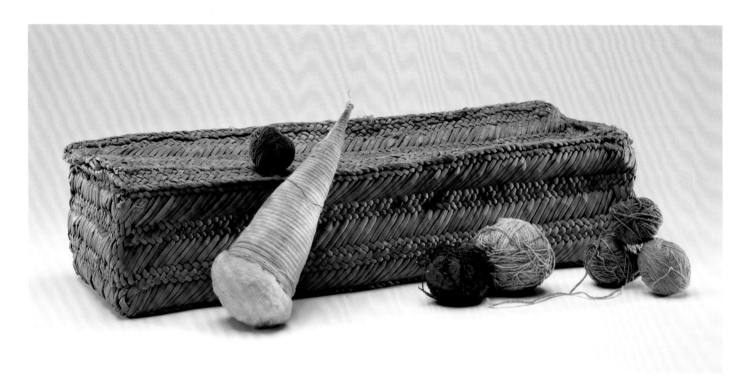

21A–C

Cone of prepared cotton ready for spinning
Central coast (?) of Peru
Pre-Columbian, date unknown
Cotton fiber, string
19 x 6 cm

Balls and skeins of yarn ready for weaving
Central coast (?) of Peru
Pre-Columbian, date unknown
Cotton, camelid hair
Dimensions various

Workbasket containing 85 spindles
Chancay culture (?), central coast of Peru
Late Intermediate Period, 1150–1450 CE
9 x 38 x 15 cm

The workbasket was used to hold the weaver's tools, including yarns, needles, and small wooden combs. These baskets were used throughout the Pre-Columbian weaver's lifetime and were buried with her.

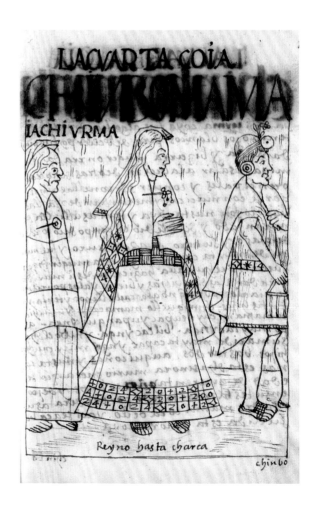

22

An Inca nobleman standing to the right of the Inca queen (center) wears a mantle over his tunic and carries his striped coca bag in his hand. His special large earplugs and elaborate headgear indicate his nobility.

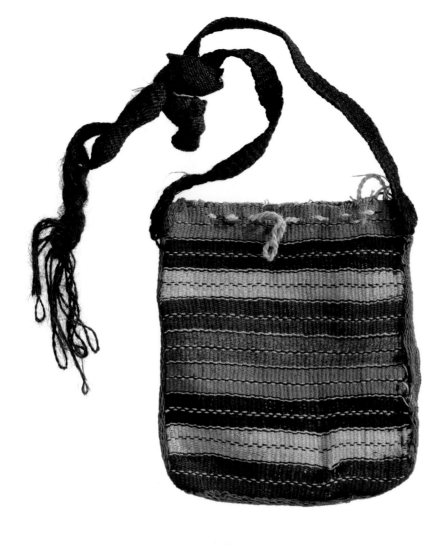

23
Coca Bag
Inca culture, unknown provenance
Inca Period, 1435–1532
Camelid hair, natural colors;
warp-faced plain weave
49 x 12 cm
FOWLER MUSEUM X71.1791;
GIFT OF DR. RUSSELL LUDWICK

Four selvages exist.

Typical of Inca coca bags, this
example has stripes composed of
natural colored alpaca hair: black,
white, brown, and coffee color.
These natural colors signify alliance
with Pachamama, the earth mother
revered by the Inca. Larger bags of
this type are known, but this small
one was woven specifically to be this
size. The strap has broken, likely
from use, and has been tied together.

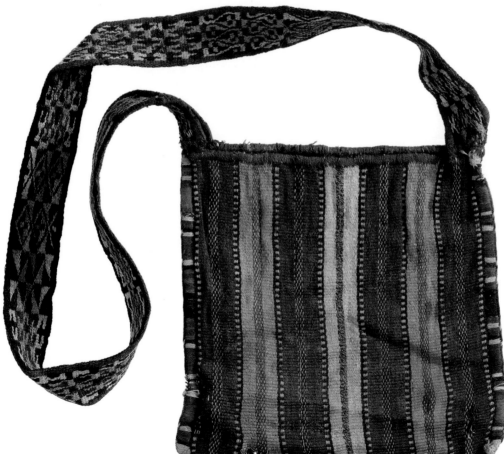

24
Coca bag with shoulder strap
Inca culture, unknown provenance,
likely south coast of Peru
Inca Period, 1438–1532
Camelid hair, natural and dyed
colors; weft-faced plain weave;
warp-patterned weave (strap)
54 x 19 cm
FOWLER MUSEUM X67.527;
GIFT OF THE WELLCOME TRUST

*Four selvages exist for the bag as well
as for the strap.*

Deceptive in its simplicity, this
bag was made by the royal Inca
weavers. Some of these bags, which
were used to hold coca leaves, have
been found in sacred offering sites
especially in the frozen highlands.
Typical of official Inca production,
the symmetrically arranged woven
stripes are created with tightly
packed wefts—as opposed to the
warp stripes in the related bag
(see fig. 23). Telltale evidence of its
weaving method can be seen in the
preserved chained warp selvage—
used only by the Inca master weav-
ers who created these bags, along
with special tunics for the nobility
(see fig. 22). The strap with diamond
designs in paired colors is woven in
a complex warp pattern, the same
technique and design used to create
special ceremonial belts that were
documented by Spanish friar and
historian Martín de Murúa and
Peruvian artist and author Guaman
Poma de Ayala in the late sixteenth
to early seventeenth century.

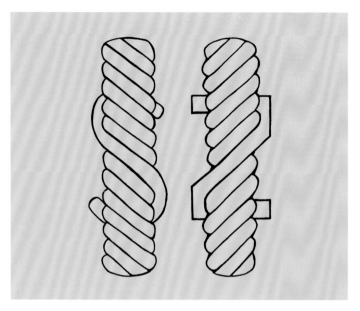

25
This illustration shows the opposed directional twist of "S" and "Z" spun yarns. DRAWING BY CHRISTIAN D. JACOBS.

26
This detail of the mantle illustrated in figure 17 shows yarn that has been overspun. The extra twist added to the yarn causes it to double over on itself, imparting stretchiness to the weaving.

27
Detail of the burial face mask illustrated in figure 9 showing the plied warp yarns.

28
This detail shows the single-ply (horizontal) wefts and double-ply (vertical) warps used in the ceremonial textile fragment illustrated in figure 8a.

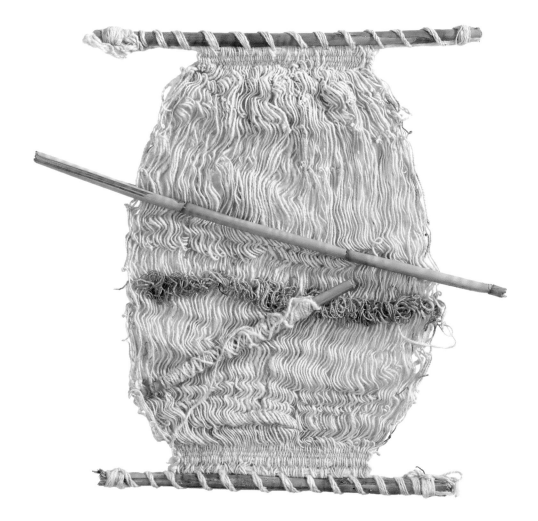

29A

Woven cotton textile in process on its loom, including loom bars, heddle rods, shuttle sticks

Unknown place of origin and date, possibly south coast (?) of Peru

Cotton warp and weft, sticks, reeds; warp-faced plain weave

27 x 14 cm

Beginning and ending woven warp selvages are extant as well as weft edges.

A Peruvian loom is a set of sticks. The warp and weft give it shape and form. Here the basic loom holds a partially woven warp. The sticks—one at each end—are the loom bars that hold the warp yarns, lashed to the set of yarns by a cord. The weaver begins at one end and inserts the wefts, using a shuttle, the small stick wrapped with cotton yarn. After a few insertions, that stabilize the selvage, the loom is turned around, and the weaver begins at the opposite end. On this particular cloth, the weaver finished only a small portion of the weaving at each end. The weaving process would have been aided by the lifting of the heddles—the darker brown loops; these loops were likely lifted with another stick, the heddle rod, which is now missing. The close spacing of the warp yarns has created a warp-faced fabric, where the warp yarns cover the wefts, which are almost invisible.

Woven Cloth: Warps and Wefts

A woven cloth is made up of a warp and a weft: the warp is the first set of yarns placed on the loom (figs. 29a,b). The weaver subsequently interlaces the weft perpendicularly across the warp. The channels or pathways that these yarns follow during the weaving process may vary in their sequence, but they generally remain in their horizontal or vertical orientation. Many different weave structures can be made, from the simplest plain weave composed of one warp and one weft to the complex double- and triple-cloth composed of multiple sets of warps and wefts—but the two essential elements, warp and weft, remain the same.

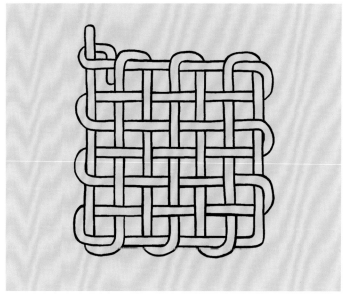

29B

This diagram shows the formation of a four-selvaged cloth in a simple plain-weave interlacement. The warp yarn turns at the lower right-hand corner to become the weft. Sometimes a separate weft yarn is used, often doubled at the beginning and ending to anchor the warp to the loom (see fig. 31). DRAWING BY CHRISTIAN D. JACOBS.

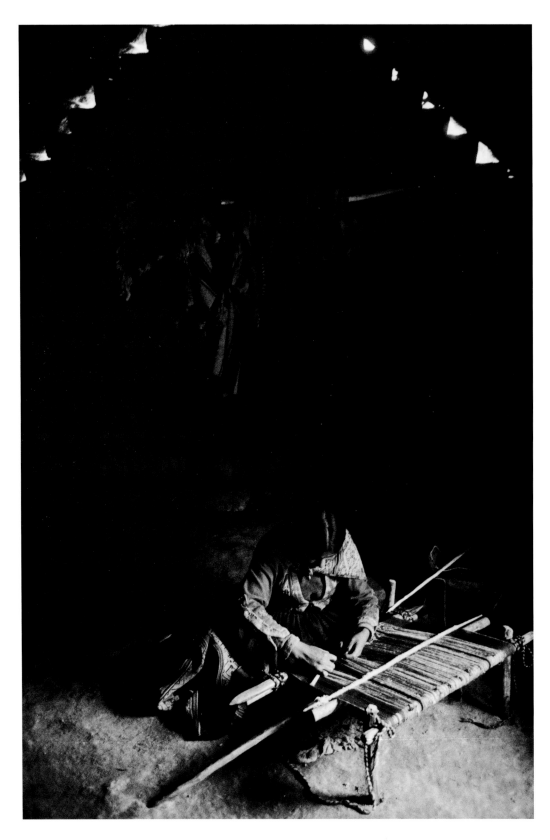

30
John Cohen (b. New York, New York, 1932)
Four-Stake Loom, Ocongate, 1956
Gelatin silver print, printed 2013
36 x 28 cm

In the Andes a weaver blesses the warp before beginning to weave (see fig. 82). The warp is created by measuring out a single yarn, wound back and forth around a set of poles or sticks. It is then transferred to the loom, maintaining the loops naturally formed as the yarn turns around each stick. Sometimes, in the highland region, the warp is wound directly around the loom bars, which have been set in place with stakes, parallel to the ground, and will remain stationary through the weaving (fig. 30). In other cases, separate poles or sticks are used for measuring out the warp, and these are later replaced with heavy cord, called the heading cord (fig. 31), which is subsequently lashed around the loom bar to hold the warp in place. The loop of the warp that was formed when it was originally laid out remains uncut after weaving; once removed from the loom, it forms the warp selvage. The creation of the warp selvage edge is a key element in Andean textile production: it begins at the warping stage and continues through the weaving process (see fig. 33c).

A selvage is formed as a yarn—either warp or weft—turns around at an end point, and returns to follow the reverse direction, remaining uncut (figs. 32a,b). The point at which it returns, forms an edge. Many non-Andean cultures create cloth with selvages in one direction only, generally the weft, which forms the side edges of the finished cloth. The weft edges, or selvages, remain uncut, while the warp ends are generally cut off the loom—except in the Andes.

The warp selvages form the top and bottom of a textile: they demarcate the beginning and ending of the weaving. Some cultures produce one warp selvage—sometimes the lower edge, sometimes the upper edge, depending on the loom. The heading cords may be differentiated from the rest of the weaving by color or thickness. They are used to hold the warps in place on the loom, and so they are often doubled or tripled to give more strength. Sometimes they are kept in the cloth after weaving, even used as decorative elements (see fig. 32b). Other times they may be removed from the cloth altogether.

Sometimes during the weaving process the final section of warp is left unwoven, yet remains uncut as well. This may be for decorative or practical reasons. Mummy face cloths, for example, often have their long, unwoven warps wound into a knot, simulating the hair of the deceased. Many examples of these face cloths have been preserved, but few have their original long warps—archaeologists and collectors appreciate their painted designs but often do not value the stringy lengths, which preserve valuable cultural information about their function within the ritual burials (see fig. 9).

Another example, a Chimu textile panel, shows preserved and unwoven warps—though in this instance, rather than being intentional, it may just have been that the weaver did not have time to complete the piece before it was needed for its ceremonial purpose (fig. 33a). The weaver would have begun at the top to secure the position of the warps (fig. 33b) by weaving only a few wefts. Then the loom would be turned around, and the weaving would have begun from the bottom up until the end of the design area was reached. The lower edge of the panel shows the way in which the warps loop around a white heading cord, which is now only partially preserved (fig. 33c).

31
This is a detail of the warp selvage at the beginning of the weaving in figure 29a, shows the loom bar with the vertical warps. Thick wefts (composed of a bundle of four or five individual yarns) are used to start the weaving, then single, individual wefts are used for the rest of the weaving. The yarns that wind diagonally around the wooden loom bar hold the heading cord (a thick weft), which in turn holds all the warps in place.

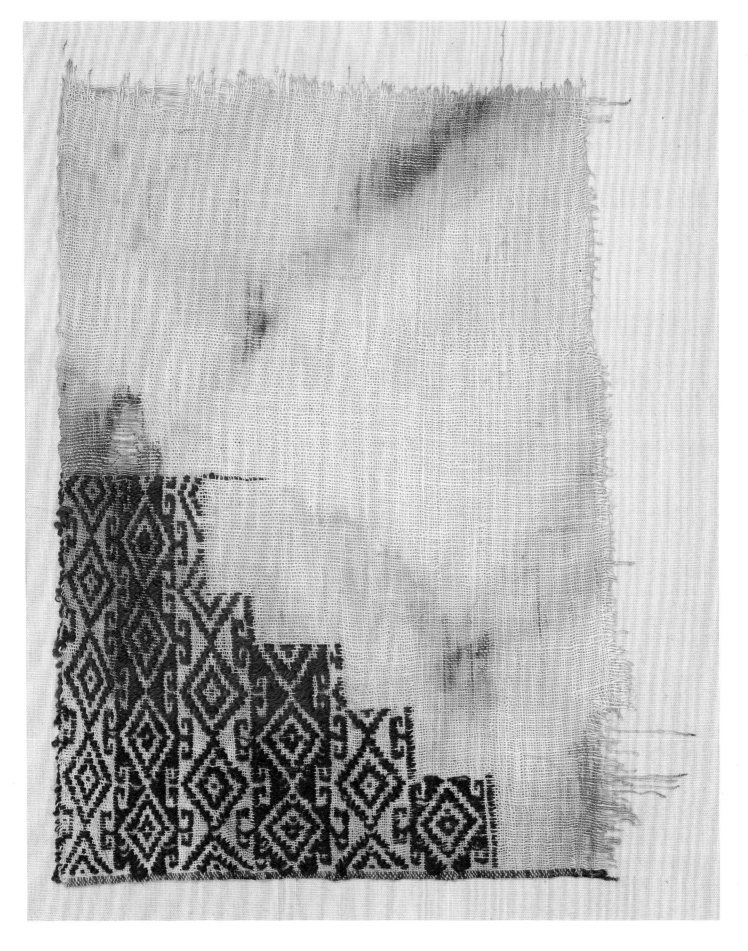

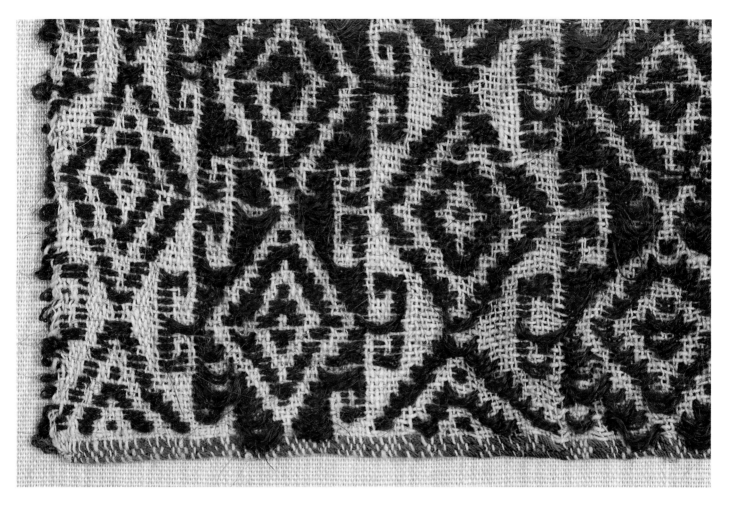

32A
Corner fragment of a textile
Nasca/Wari culture, Nasca Valley, south coast of Peru
700–900 CE
Cotton, dyed camelid hair; plain weave with supplementary-weft patterning
39 x 26 cm
FOWLER MUSEUM X65.8778; GIFT OF THE WELLCOME TRUST

Two selvages have been preserved: one warp and one weft.

This corner fragment was probably once part of a wider panel that would
have had another corner embellished in a mirror image of this one. This
panel in turn would likely have had a mate, which would have been stitched
to it, forming a larger cloth with all four corners embellished. Beautifully
woven, most textiles of this type utilize geometric designs that follow the
grid of the cloth, though only in the corner area, leaving the rest of the cloth
undecorated. Some of the designs form abstracted animal features, while
others construct the step and wave motif that is seen in a number of other
textiles, especially tunics (see figs. 42–45).

32B
Detail of figure 32a showing colored heading cord.

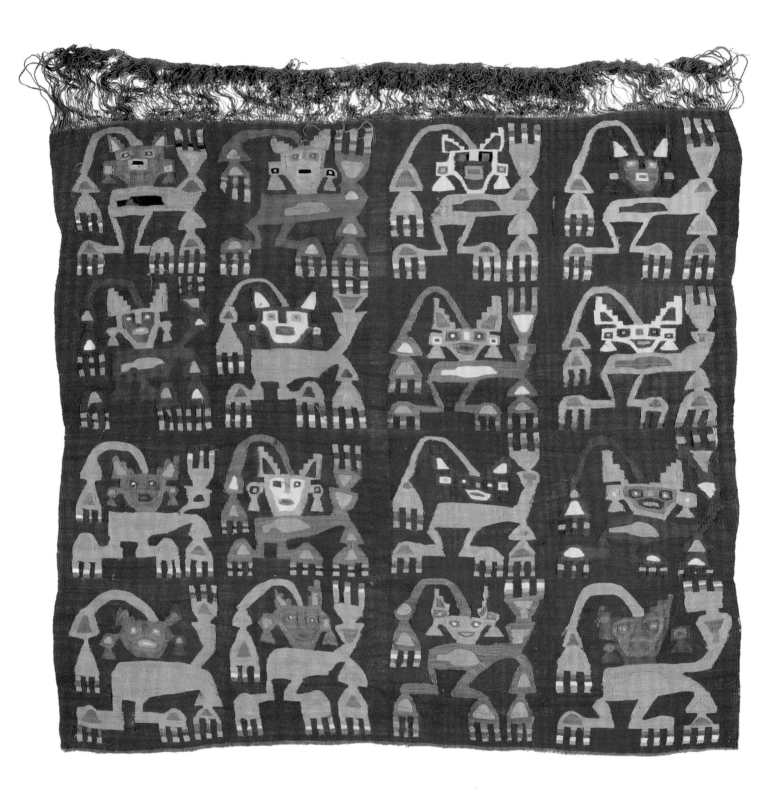

33A
Panel with crowned figures bearing staffs
Chancay or Rimac culture, central coast of Peru
Late Intermediate Period, 1150–1450 CE
Natural brown cotton warp (S-spun, Z-plied), dyed camelid hair; weft
(Z-spun, S-plied); tapestry weave with slit joins and eccentric weft
77 x 74 cm
FOWLER MUSEUM X65.8730; GIFT OF THE WELLCOME TRUST

All four selvages are preserved; there are unwoven warp ends at the top.

Wearing a double-pointed crown and large earplugs, a sign of high status, the somewhat abstracted and eccentric figures bear royal staffs. They may represent kings or composite three-fingered, three-toed mythical creatures. This lively panel appears unfinished at the top, with a section of unwoven warps; perhaps it was needed for a royal burial, and there was insufficient time to complete it. The cochineal red background was a color favored in the region, and the natural brown-colored warps, along with their spin direction (S-spun, Z-plied) was more typical of the northern coastal part of the empire of the Chimu.

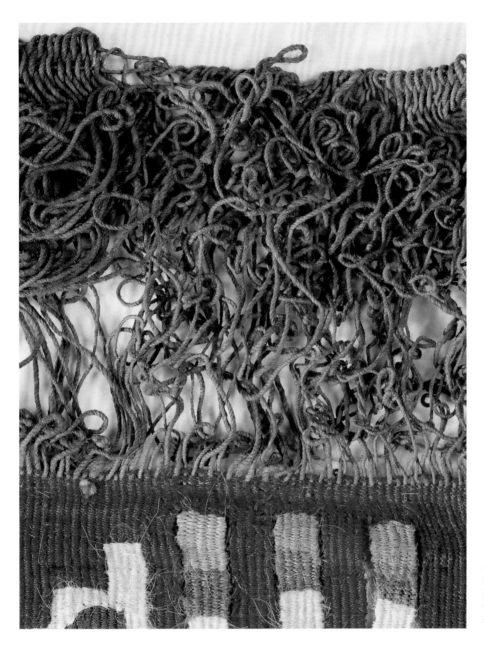

33B
Detail of the upper warp selvage of figure 33a showing that just a few wefts had been woven at the top to secure the warps.

33C
Detail of the white heading cord at the lower warp selvage of figure 33a.

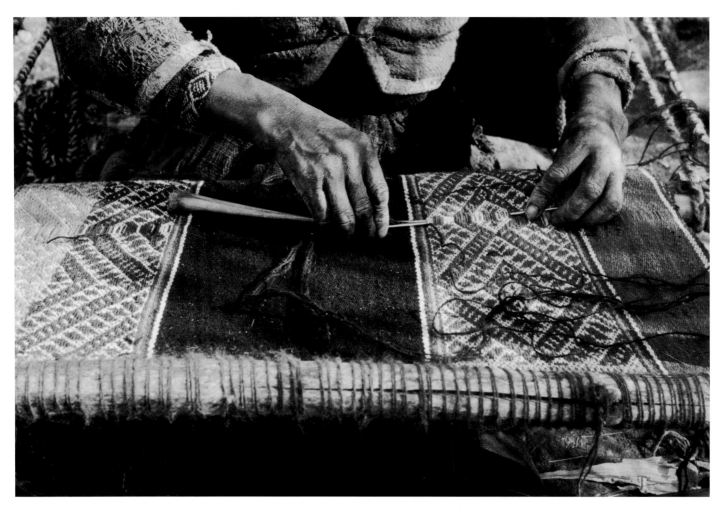

34
John Cohen (b. New York, New York, 1932)
Inserting Final Passes of Weft Using a Needle, near Ocongate, 1956
Gelatin silver print, printed 2013
28 x 36 cm

There are reasons why very few cultures around the world produce cloth with both warp edges uncut. The first is practical. If the warp threads are not cut, the weaver is confined to a set dimension, and during weaving, the yarns become tighter and tighter (and the space in which to work narrower and narrower), making it difficult to insert the final wefts as the fabric nears completion. This last section of the weaving, referred to as the "terminal," must be completed with threaded needles and requires meticulous concentration in order to maintain structures and patterning (figs. 34, 35a,b).

A second reason is technical and relates to the parts of the loom—among them reeds and fixed heddles—that do not usually appear in the Andes. Most looms require the individual warp ends to be threaded into the reed and a set of fixed heddles (generally string or metal eyelets). These two loom components are used by many cultures to help maintain the proper spacing of the yarns (the reed) and to assist with the lifting of a set sequence of yarns for regular, repeated interlacement during weaving (the heddles). In the Andes, however, both warp ends remain uncut and therefore cannot be threaded into such pre-made components. The warps are instead placed onto the loom, and only after that are individual heddles created around them (fig. 36). These heddles, generally made of a separate yarn, are looped around the appropriate warps (every other warp, for a plain-weave textile). Each time a warp is set up on the loom, the heddles must be re-created for that particular piece.[4] One scholar who worked in the field of highland Peru for many years cogently remarked that an Andean loom is only a loom when it has a warp on it; otherwise, it is just a series of sticks (fig. 37).[5]

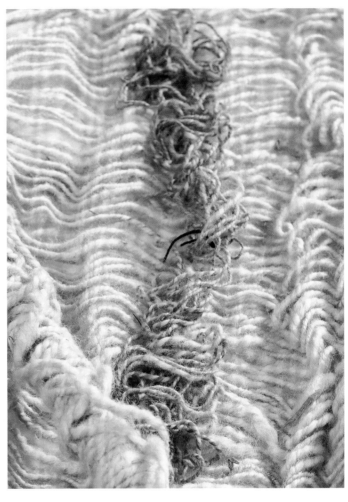

35
Detail of the Andean loom seen in figure 29a, showing brown heddle yarns in place.

36A,B
Needle case
Camarones, Chile
Pre-Columbian, date unknown
Leather or skin
16 x 5 cm
FOWLER MUSEUM X66.1968;
MUSEUM PURCHASE
NOT IN EXHIBITION

Needle case with pins and needles
Nasca culture, south coast of Peru
Early Intermediate Period,
100–600 CE
Reeds, cactus
13 x 3 cm
FOWLER MUSEUM X86.2897; GIFT OF
MR. AND MRS. HERBERT L. LUCAS, JR.
NOT IN EXHIBITION

Cases such as these were used to protect fine needles.

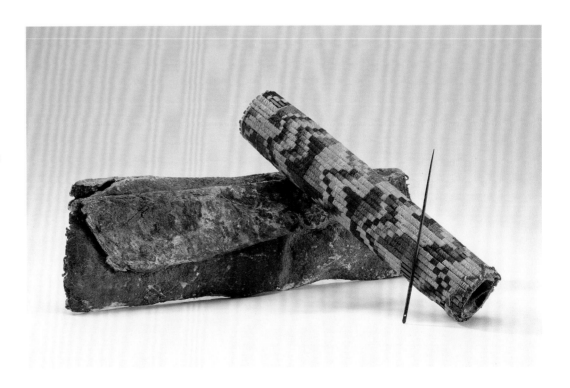

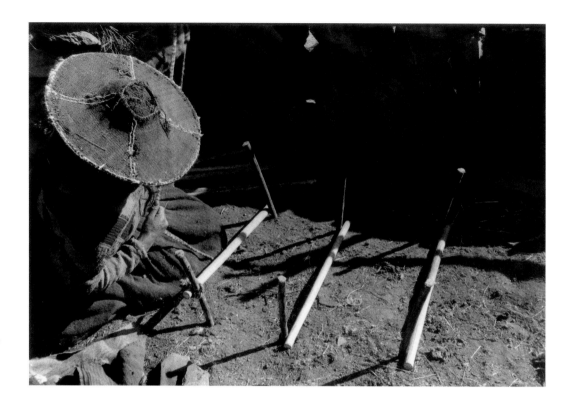

37
John Cohen (b. New York,
New York, 1932)
"Laying out three loom bars
for special warp (Q'eros)"
Mid-1950s
Black and white photograph
COPYRIGHT JOHN COHEN, REPRODUCED
WITH PERMISSION FROM *PAST PRESENT
PERU: ANDEAN TEXTILES* (STEIDL, 2010)
NOT IN EXHIBITION

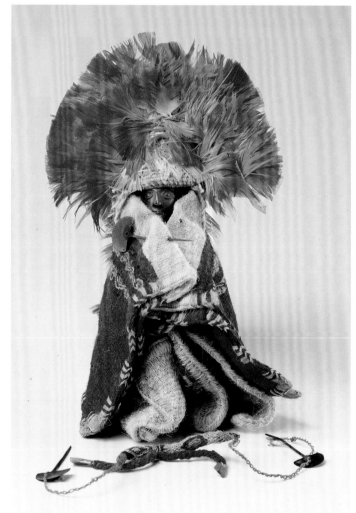

38
Inca miniature figure
Inca culture, Túcume, Lambayeque Valley, Peru
Inca Period, 1438–1532
Silver, camelid hair, feathers, spondylus shell, bast fiber
H: 17 cm
MUSEO DE SITIO TÚCUME, LAMBAYEQUE, PERU, ACC. NO. RHLTPS 195
PHOTOGRAPH BY DANIEL GIANNONI
NOT IN EXHIBITION

This silver female figurine is fully dressed in Inca-style miniature
garments, including a wrapped dress, mantle, feather headdress, silver
dress pins, and belt.

Andean looms can be composed simply of two or four sticks and can be used horizontally staked to the ground (see fig. 30), vertically, leaning against a wall (see fig. 80), or tied to the weaver's waist (see fig. 84). The ways in which these looms are set up and used relates to the need for the warp to be under uniform tension for weaving. The ground-staked loom, for example, holds the yarns very taut: this is used mostly in the highlands for warp-faced weaving. The backstrap loom in contrast, is fixed at one end to a stationary point—a post or tree, for example—and at the other end, tied around the waist of the weaver. The weaver can move back and forth, tightening or easing the tension on the warp yarns, which in turn enables her to lift the appropriate yarns to insert the weft.

In non-Andean cultures where cloth is woven as one long length, such lengths are used for many purposes. They can, for example, be cut into pieces and fabricated into a garment that is sewn from many segments fitted together to form the shape of a coat or dress. The joining of lengths of cloth enables increasing the overall width, length, or both. Furthermore, a fabric, once woven, can have many purposes over time. If used initially to construct a woman's dress, it may later be refashioned into another item of a different style or cut down for a secondary use.

In the Andes, however, this is rarely the case. A woven cloth is made to be something specific and unchanging. Once a piece of rectangular cloth is woven as a garment for a man, it would not be repurposed for a woman's garment. Similarly, a child's garment would not be made from a cloth cut down to size; rather, it would have been woven specifically for the child in the child's size. Even the miniature garments used for clothing statues offered to the gods—such as Yllapa, the god of lightening, or the sun god worshiped by the Inca—were woven to the exact size of the tiny figurines they clothed (figs. 38, 39). The Inca even had specialist artisans whose role it was to weave these miniature garments, as well as weavers dedicated specifically to making cloth worn by sacrificial llamas.

39
Miniature tunic with staff bearers
Wari culture, southern highlands of Peru
800–850 CE
Cotton warp, camelid-hair weft; tapestry weave
16 x 26 cm
PRIVATE COLLECTION
NOT IN EXHIBITION

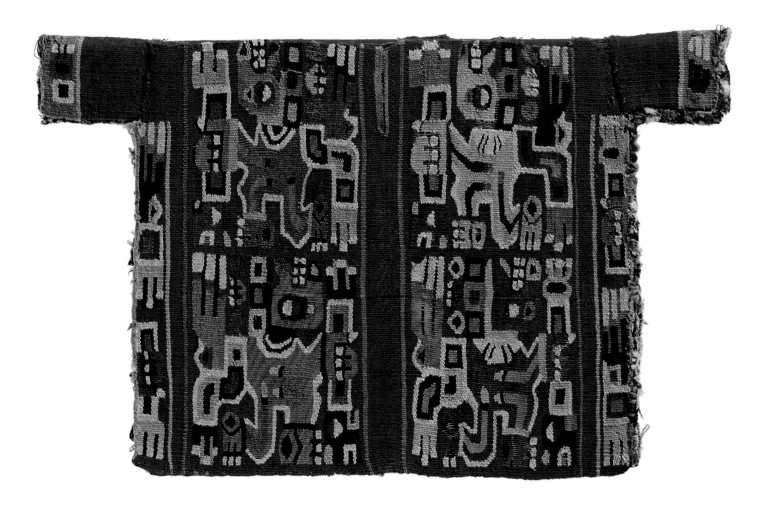

40
Panel with four decorated corners
Wari culture, Peru
7th–9th century
Cotton, camelid hair
178 x 178 cm

COMPOSING ITEMS WITH FOUR-SELVAGED CLOTH

Sometimes a single panel of four-selvaged cloth is sufficient, as for a man's mantle. Often, however, two or more units of cloth must be seamed together, as when making a woman's mantle (*lliclla* in Quechua or *phullo* in Aymara, the two main languages of the Andean region). Each of the two units of cloth is called a *callu*, meaning half of something. Even though each is woven as a complete cloth with all four edges, it is conceived as incomplete without its pair. Designs on these cloths are asymmetrical when viewed as single units. Once the two are seamed down the center, however, the whole becomes symmetrical.

Even though many of the textiles that remain from the archaeological record are not preserved in their entirety, the remaining fragments reveal a surprising number of selvage edges. Selvages are often the strongest part of a textile because the return of the threads serves as a kind of reinforcement. In addition many Andean cultures add reinforcing (and decorative) stitching to the edges of the cloth. When two pieces of cloth are seamed together, generally the stitching binds the selvage edges. Given the factors of age, burial, and rough removal from archaeological settings, it is often only the selvage edges that remain. Warp and weft selvages, even in fragmentary form, can be differentiated by looking closely at a textile, because they serve separate functions in the cloth. Weft selvages are generally simple: occasionally, strong cords are used to hold the wefts as they turn around. Warp selvages are often created with thick, heavy yarns that hold the warp strands in place.

In the Andes edges matter in more ways than one. Corners and edges define the space of a textile, and embellishments are often found that emphasize them. Sometimes this is functional, for example, adding weight to a garment so that it hangs in a particular way when worn. Tassels and braids at the end of a belt may help with wrapping or tying it around the body. Edges and corners, however, may also carry more esoteric meanings that are concerned with protecting the spirit of the cloth by maintaining it within the panel. In modern day Bolivia, Aymara weavers use special yarns at selvages, called *lloque*, to protect the spirit of the cloth. These yarns are spun in a direction opposite to the yarns used for the rest of the cloth, and they are generally used only at the outer edges. While this tradition has not yet been found in the pre-Columbian textiles, many other creative aspects and details appear at the edges of ancient four-selvaged cloths (figs. 40–45, and see figs. 32a,b).

41
Textile panel with corner design
Nasca/Wari culture, Nasca Valley, south coast of Peru
Circa 700–900 CE
Cotton, natural and indigo-dyed; plain weave with weft-float patterning
127 x 47 cm
FOWLER MUSEUM X65.11861; GIFT OF THE WELLCOME TRUST

This panel is complete with all four selvages. (It was intended as one of two that would have formed a larger cloth.)

A cloth with one decorated corner begs to be completed with a companion panel. A related textile with four extant corners and a very similar design and layout was found in Monte Grande in the Nasca Valley. Sometimes two or three panels like this one are used to form a square cloth that has burial associations and may form part of a garment or special wrapping cloth.

42

Corner fragment of a textile
Ancon (?), central coast of Peru
Late Intermediate Period (?),
1150–1450 CE
Cotton, camelid hair, dyed; plain
weave with supplementary-weft
float patterning
34 x 27 cm
FOWLER MUSEUM X65.5108;
GIFT OF THE WELLCOME TRUST

*One warp and one weft selvage have
been preserved.*

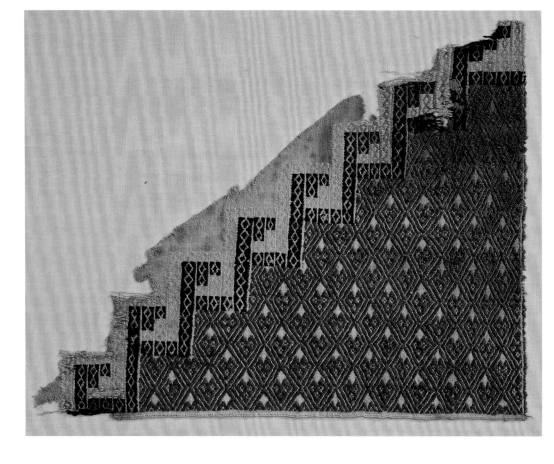

43

Corner fragment of a textile
with birds
Chancay culture (Caqui),
central coast of Peru
Late Intermediate Period,
1150–1450 CE
Cotton warp (Z-spun, S-plied),
camelid-hair weft (some single
Z-spun, others Z-spun, S-plied),
natural and dyed colors; tapestry
with weft-float patterning (plain
weave area has been cut away)
11 x 12 cm
FOWLER MUSEUM X72.522;
GIFT OF LEO DRIMMER

*The fragment has both side selvages
and bottom selvage preserved. The
stepped area has been cut, but the ends
have been finished.*

Birds are represented on textiles,
ceramics, and architecture through-
out the central coast. In this fragment
of a stepped corner, they are woven
in two methods: as small charming,
individual long-beaked birds made
in tapestry and as part of the stylized
design fretwork underneath. The
geometric-style patterning mimics
the designs on brickwork and stucco
friezes found on the walls of palaces
of the coastal empires. This narrow
fragment may have been part of a
larger garment, and in that case, it
likely had a companion corner, which
would have had the same steps
running in the opposite direction to
create a mirror image. The red dye
is cochineal.

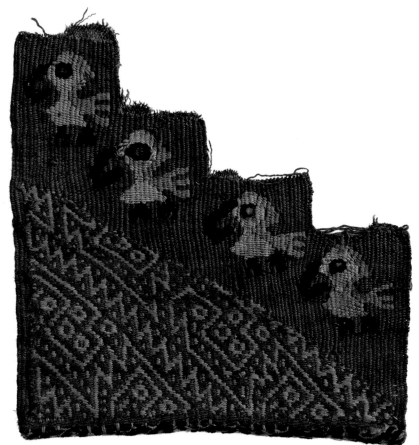

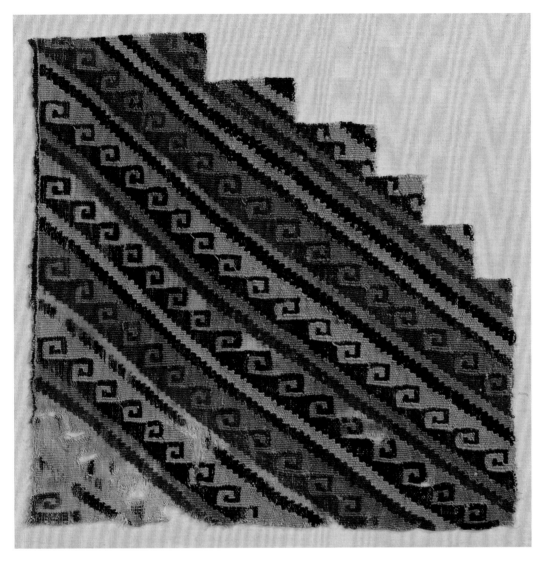

44
Corner fragment of a textile
Nasca/Wari culture, south coast
of Peru
700–1100 CE
Cotton, camelid hair, dyed; plain
weave with supplementary-weft
float patterning
29 x 28 cm
FOWLER MUSEUM X65.12297;
GIFT OF THE WELLCOME TRUST

Remnants of two selvages are preserved.

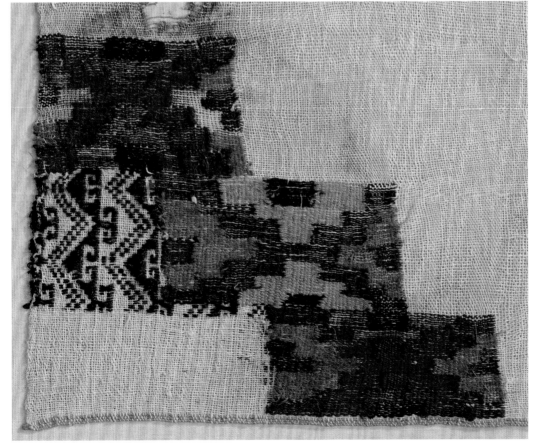

45
Corner fragment of a textile
Nasca/Wari culture, Nasca Valley,
south coast of Peru
700–900 CE
Cotton, camelid hair, dyed; plain
weave with supplementary-weft
float patterning (reinforced tapestry)
36 x 33 cm
FOWLER MUSEUM X65.11879;
GIFT OF THE WELLCOME TRUST

*One warp and one weft selvage are
preserved.*

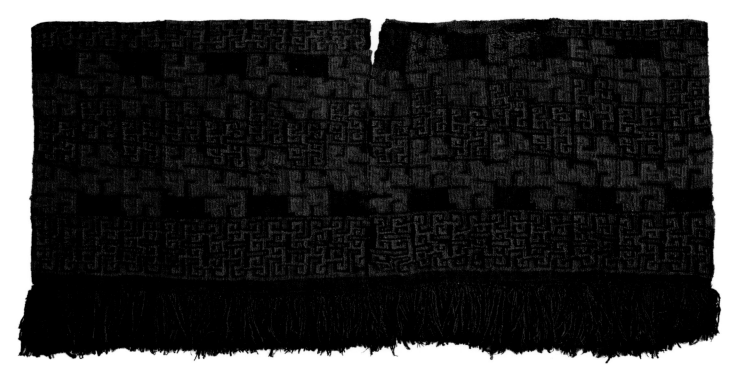

46A,B
Short Tunic
Nasca/Wari culture, south coast of Peru
Early Intermediate Period/Early Middle Horizon, circa 500–800 CE
Camelid-hair warp (Z-spun, S-plied; red, blue, brown—sometimes two used together) and weft (Z-spun, S-plied); tapestry weave with interlocking joins, fringe
73 x 33 cm
FOWLER MUSEUM X86.2934; GIFT OF MR. AND MRS. HERBERT L. LUCAS, JR.

Two four-selvaged panels are stitched together; separately woven fringe is stitched along bottom edge.

This short, wide garment is a ceremonial tunic. Its densely woven tapestry surface uses highly contrasting blue and orange to create the Nasca Proliferous-style geometric scroll designs that evolved from earlier graphic depictions. The material and technical composition may indicate highland influence. The thickly formed fringe was separately woven and then added to the bottom edge to give weight and body to the garment.

Fringe (figs. 46a,b), tabs (figs. 47a,b), woven bands (figs. 48a,b), embroidery (fig. 49), and other techniques (fig. 50) were also used to emphasize and decorate the edges of pre-Columbian textiles. In many cultures fringes result from cutting the lengths of warp yarns that remain unwoven off the loom. In the Andes, however, fringes are usually woven separately and then stitched to a cloth when needed, and even in this case they may be four-selvaged units. (Often a yarn is woven and then removed after completion, freeing up the yarns to act as a fringe.) The creation of woven fringes and rectangular tabs is an ancient tradition in the Andes. In some of the earliest representations of the deities worshiped by the Chavin culture, the gods are depicted wearing garments with tabs. It may be that this type of edging was used on ceremonial garments associated with ritual processions or dance.

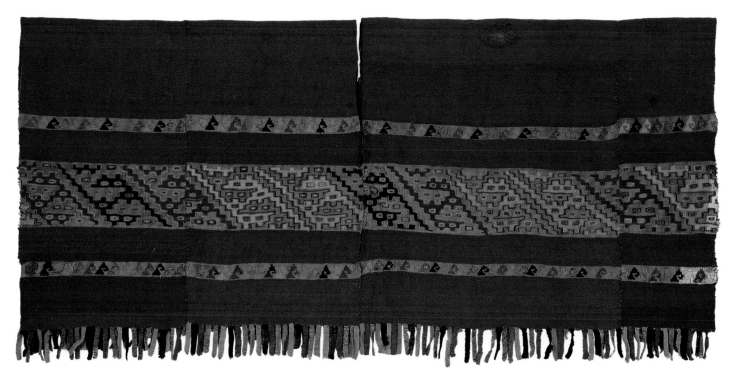

47A,B
Tunic
Chimu culture, north coast of Peru
Late Intermediate Period, 1150–1450 CE
Cotton warp (3-ply, Z-spun, two-toned white and brown), camelid-hair weft (Z-spun, S-plied), dyed; weft-faced plain weave and tapestry, slit joins
90 x 43 cm
FOWLER MUSEUM X86.3965; GIFT OF MR. AND MRS. HERBERT L. LUCAS JR.

Two four-selvaged panels are stitched up the middle. The woven tabs that make up the fringe are continuous warp.

Four narrow panels stitched together and folded at the top were used to create this short, wide male upper garment or tunic. It has a beautifully woven cochineal red surface with diagonally aligned abstract designs of camelids and birds. The tabs were woven on extended bi-color twisted warp yarns. The outlining of the design is made in some areas by wrapping the colored weft yarns around a single warp. Small open slits between design areas are a feature of this finely woven garment. The high-quality camelid yarns give it a silky sheen.

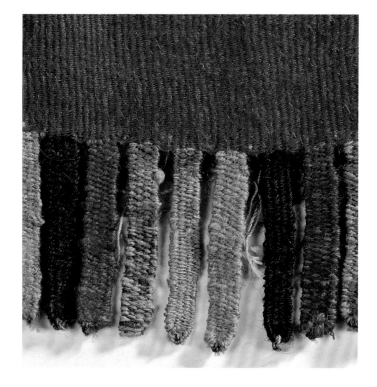

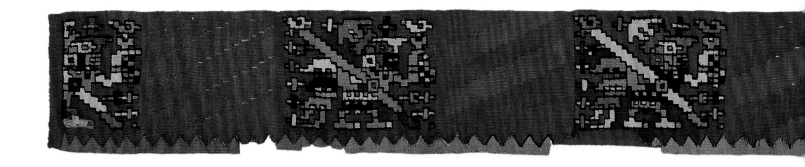

48A

Tapestry-woven band with warriors, fragment from a tunic
Moche culture, north coast of Peru
Early Intermediate Period, 100–800 CE
Cotton warp (Z-plied), camelid-hair weft (Z-spun, S-plied), dyed;
tapestry weave with slit and dovetail joins
124 x 19 cm

This separately woven band has three of its four selvages preserved.

The bold Moche figures on this band wear elaborate headdresses, and
each holds a shell in one hand and a long staff in the other. Carrying their
accoutrements, they appear to be walking in a kind of ritual procession.
The figures are composed in tapestry weave with color blocks formed using
slits that create openings in the cloth. This band, woven separately as a
complete section, would have been added to the lower part of a tunic. The
zigzag design along the lower edge would have created the finishing touch.

48B

Detail of a Moche warrior wearing an elaborate headdress from figure 48a.

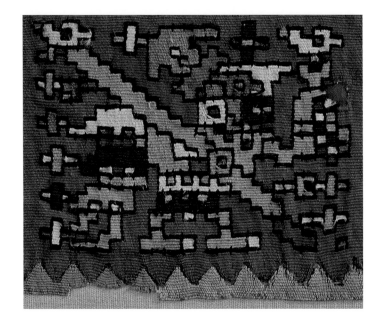

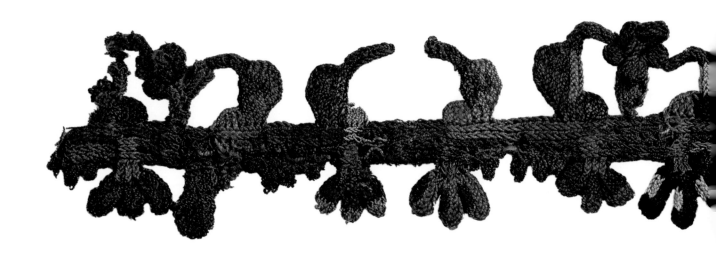

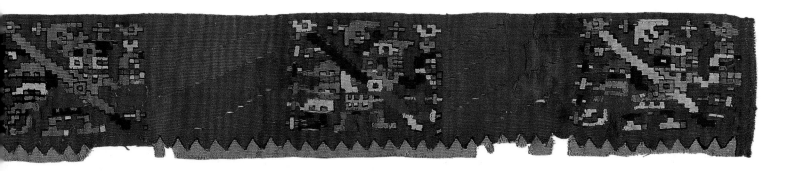

49
Detail of the embroidered edging
on the bag illustrated in figure 55.

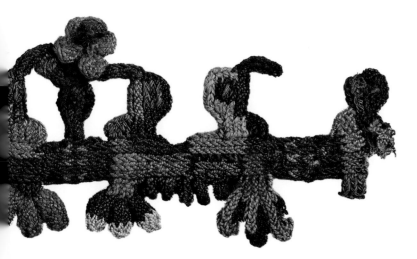

50
Fragment of decorative edging from a mantle
Nasca culture, south coast of Peru
Early Intermediate Period, 1st–3rd century CE
Dyed camelid hair; three-dimensional crossed-looping
36 x 6 x 1 cm
FOWLER MUSEUM X80.837; GIFT OF DR. AND MRS. EDWIN ULLMAN

This fragment does not include the beginning or ending of the looping.

Three-dimensional edgings were a special skill developed by the needle-
workers of the Nasca Valley, especially during the first to around the third
century. Used to embellish generally plain monochrome mantles, these
elaborately constructed pieces are unparalleled. Created meticulously,
loop into loop, the hummingbirds birds in this band—a favorite subject
that is also depicted in Nasca ceramics—dip their long beaks into flowers.

GARMENTS

Used for ceremony and often featured in ritual burials, where they have been preserved, Andean garments include a wide variety of styles and types, created in a number of different weaves. Generally, though, they are composed of rectangular units of four-selvaged cloth stitched together. Men wore short or long tunics covering the upper body (fig. 52) and used a loincloth, which could take the form of a "skirt" or waist cloth. Over this they occasionally tied a rectangular outer mantle (fig. 51). Women's garments were wrapped dresses, composed of larger rectangular cloths, which were generally pinned at the shoulder and belted. They were worn with a shoulder mantle or shawl. Extant women's garments are more rare, and because they tend to be strictly rectangular cloths, they can be difficult to identify. The only examples in this book may be the simple white shawl (see fig. 17) and the woven belt (figs. 53a,b).

Men's tunics were sometimes made of a single cloth, folded and stitched up the sides. To create a neck opening, weavers, such as the Inca, ingeniously insured that no cutting of threads would be necessary. They prepared the loom using an extra cord to hold the warp in two sections—as for discontinuous warp textiles (see below)—and this enabled them to separate the neck section after weaving. Most cultures though created the tunics in panels, stitching them up the center and thus easily leaving an opening for the neck. The weaver usually took great care to match the panels so that they appear as one cloth. Though, at times, we can find clearly mismatched panels (fig. 54).

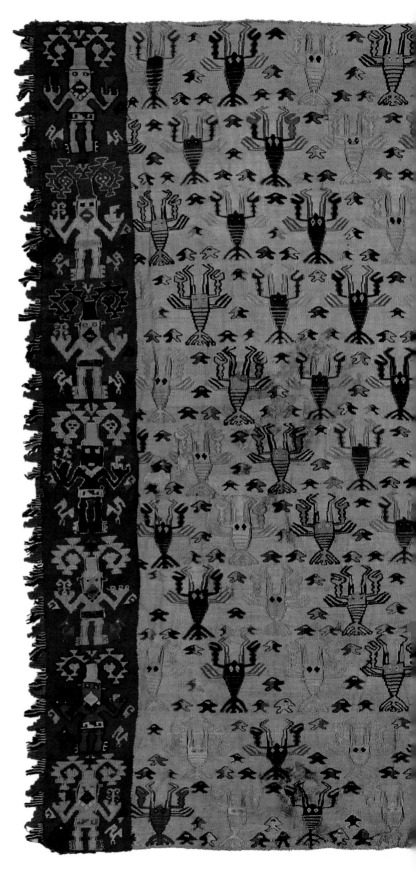

51
Tapestry panel with crayfish motifs
North or central coast (?) of Peru
Late Intermediate Period, 1150–1450 CE
Crayfish panels: Cotton warp (Z-plied) camelid-hair weft (Z-spun, S-plied); tapestry weave, slit joins
Brown panels: cotton warp (Z-spun, S-plied) and weft (Z-spun) with camelid hair; plain weave with supplementary wefts and weft-faced patterning
End tapestry panels with figures: light brown cotton warp (Z-spun, S-plied), polychrome camelid-hair weft (Z-spun, S-plied); tapestry weave, slit joins
Woven edgings: camelid hair; plain weave
161 x 112 cm
FOWLER MUSEUM X86.3950; GIFT OF MR. AND MRS. HERBERT LUCAS, JR.

Seven panels are stitched together: all side selvages and some warp selvages are preserved.

Crayfish were depicted on ceramic vessels from the coastal cultures of the Moche in the north and the Nasca in the south as early as the first century CE, although their representation on textiles is rare. This special mantle, made at a later period, is composed of several different types of separately woven panels stitched together. The two red outer panels each show standing figures with bifurcated headdresses. Each figure holds a curled wand in one hand and a stepped object in the other. This same shape is echoed in the specially woven striped edging, physically constructed as small tabs that are made as stepped forms. The three crayfish-design panels repeat the motif following diagonal color bands: when observing the panels together, the alignment of the diagonals appears as a zigzag or wave pattern. The tapestry weaver created the outlines of the figures with single lines of colored wrapping, an intensive and especially time-consuming technique.

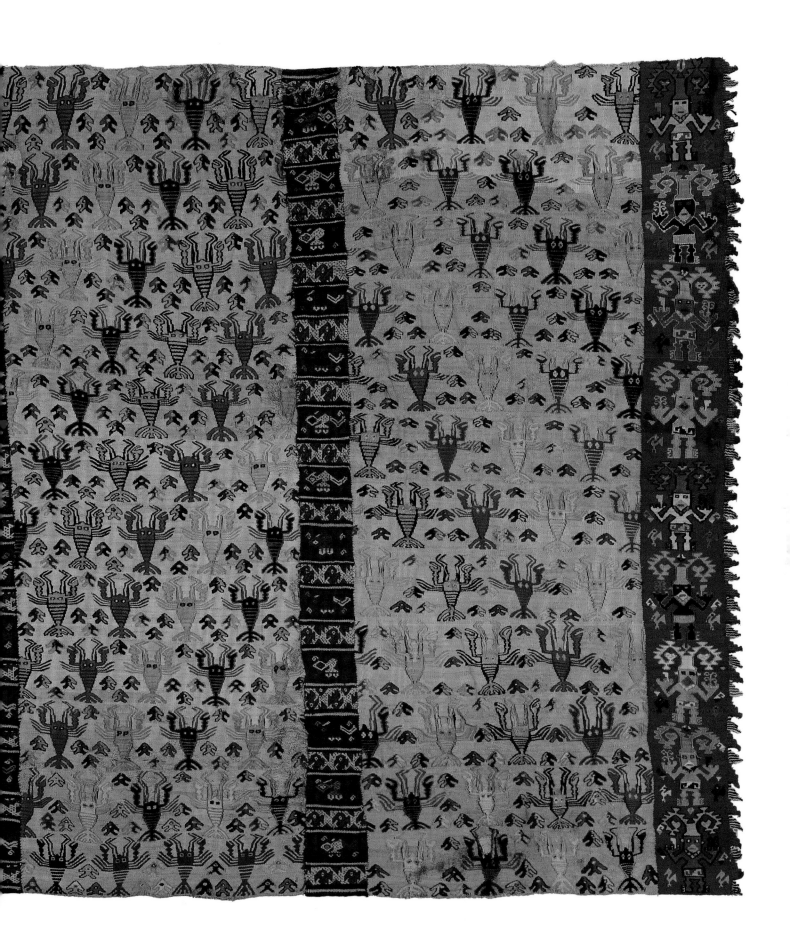

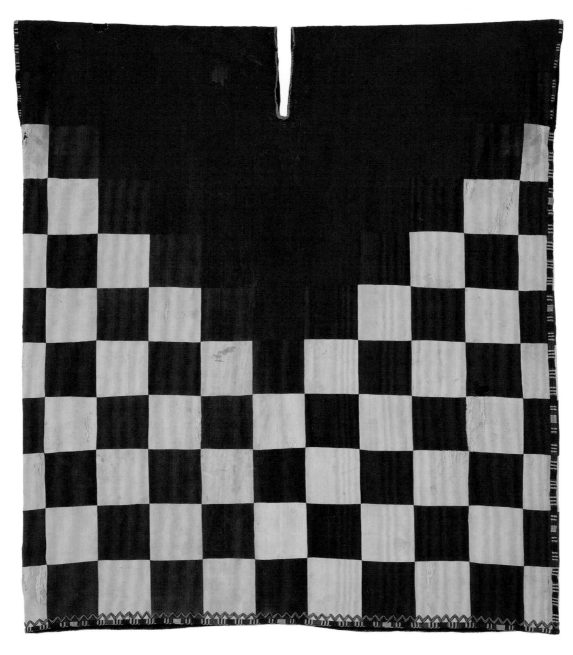

52

Tunic

Inca culture, south coast of Peru

Inca Period, 1438–1532

Cotton warp (3-ply, S-direction), camelid-hair weft (Z-spun, S-plied), camelid-hair embroidery; tapestry weave with interlocked joins, woven neck slit, embroidered edges

88 x 81 cm

All selvages are present, including those along the neck slit.

Checkerboard tunics are the quintessential Inca garment, worn by the elite army of the Inca king. When describing the battle with the Inca, Spanish conquistador Francisco Pizarro noted that they appeared like "chessmen." Woven in fine alpaca yarns, the double-faced tapestry-weave tunic was made by master weavers of the Inca, the *cumbicamayo*. Such tunics were generally woven as a black and white checkerboard, but here the black has been substituted with brown, which may have originally been darker. The cochineal red neck yoke, called *ahuaqui*, was also an integral part of the army uniform. The tunic was woven as a single piece of cloth with the warp yarns running horizontally across the chest. The neck opening was woven in using special scaffolding yarns so that it would not need to be cut later. The finishing of the edges with tightly worked embroidery completes the garment, covering the entire perimeter and creating a tunic that is identical front and back, inside and outside.

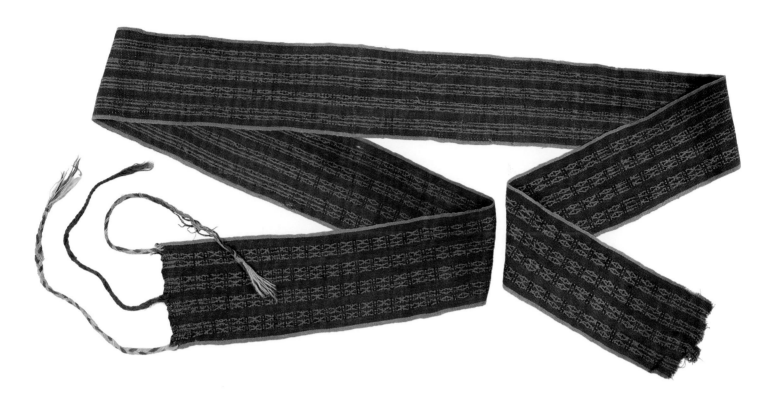

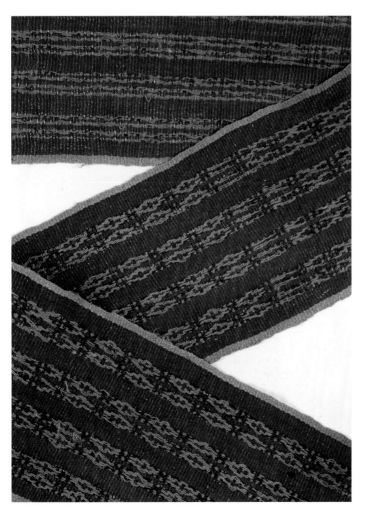

53A
Woman's sash (*mama chumpi*?)
Inca culture, highland tradition, likely preserved on the south coast of Peru
Inca Period, 1438–1532
Camelid-hair (Z-spun, S-plied) warp and weft; warp-faced plain weave
with warp-float patterning; added twisted ties
257 x 13 cm
FOWLER MUSEUM X65.11856; GIFT OF THE WELLCOME TRUST

Three of the four selvages are preserved.

This long belt patterned with stripes and geometric designs is woven in
the highland tradition of warp-faced weaving and may have been part of
a woman's garment ensemble. Its long length would secure the *anacu*, or
wrapped dress, worn by women following the Inca tradition. Special belts
called *chumpi* were worn by Inca women of high status for festivals and
ceremonial occasions. Wide belts were referred to as *mama chumpi* (mother
belt). This belt, five inches wide by almost eight feet long may have belonged
to this special category.

53B
Detail of edge of figure 53a. Note the difference between front and back
of the warp patterning, as the yarns float on the front but not at the back.

54

Tunic
Chancay culture, central coast
of Peru
Late Intermediate Period,
1150–1450 CE
Cotton warp (S-spun), camelid
hair (plied); tapestry weave
34 x 124 cm
FOWLER MUSEUM X86.3949; GIFT OF
MR. AND MRS. HERBERT L. LUCAS JR.

*Two four-selvaged panels are stitched
together.*

Birds designed in stepped-block
patterns that are diagonally aligned
recall the brickwork walls that
line the temple complexes of the
archaeological sites of the central
coast. A wave pattern appears
along the lower edge.

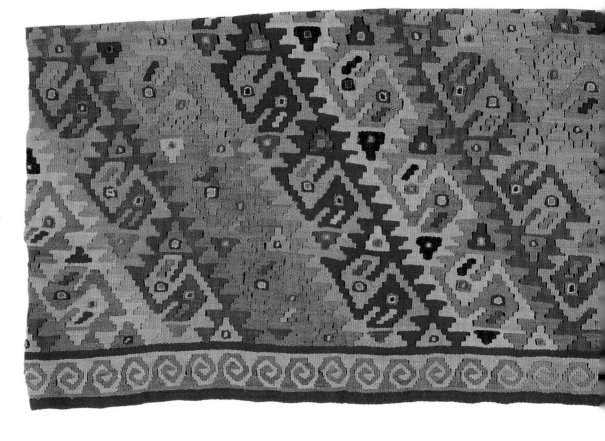

55

Trapezoidal bag
Coastal Wari style, Nasca Valley (?), south coast of Peru
Middle Horizon, circa 600–1000 CE
Cotton warp, camelid hair weft; weft-faced plain-weave with crossed-loop
stitch embroidery
21 x 8–9 cm
FOWLER MUSEUM X67.520; GIFT OF THE WELLCOME TRUST

All four selvages are preserved.

Woven in miniature, this bag was created in a trapezoidal shape. Coca bags
with this special shape, both small and larger versions, are associated with
the cultures of the far south coast of Peru and northern Chile, notably from
the time of the Wari, who were best known for their fine tapestry-woven
tunics. Like the tunics, this bag, with its finely woven weft-faced surface,
was made with luxurious camelid hair yarns tightly packed together during
weaving. Creating such small items of this quality is a difficult task, accom-
plished with fine needles, which were also used to embroider the elaborate
edgings that complete the bag's shape. See figure 49 for a detail of the
edging of this bag.

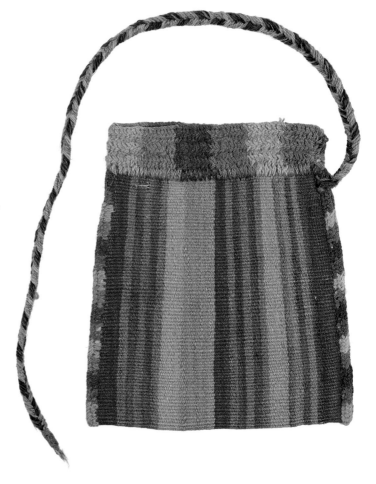

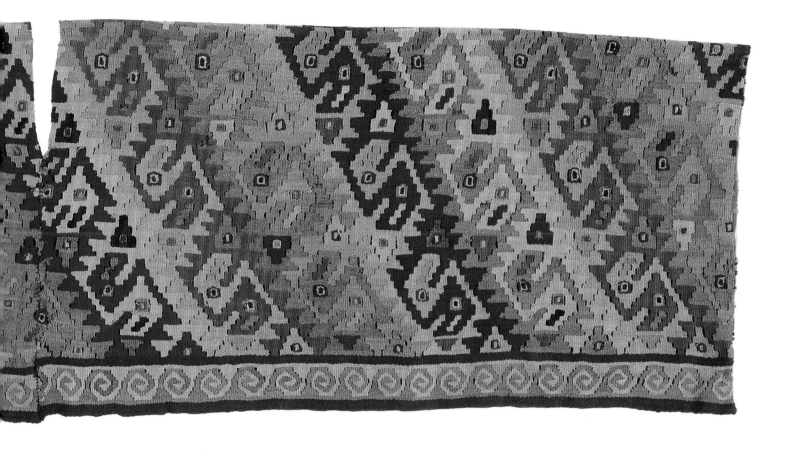

BAGS

Special bags, large and small, plain, striped, and patterned, were woven throughout the Andes to hold one precious item: coca leafs. These leaves were chewed by the people of the highlands for their narcotic effect, which lowered blood pressure and increased stamina for work at high altitudes with minimal oxygen. Coca was one of the primary items offered to the gods, and some bags were used especially in burials to accompany the dead. Bags were woven to a desired size and shape, often with a separately woven strap. They could be worn slung over the shoulder, wrapped around the wrist, tied to a belt, or displayed on the outside of a mummy bundle (figs. 55, 56, and see figs. 22–24).

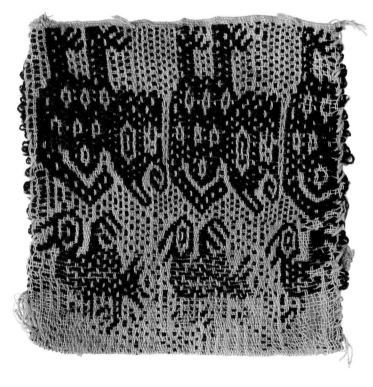

56
Bag
South coast of Peru (?)
Middle Horizon (?), 600–1000 CE
Cotton and camelid hair (Z-spun, S-plied); plain weave
with supplementary-weft patterning
11 x 11 cm
FOWLER MUSEUM X67.518; GIFT OF THE WELLCOME TRUST

Four selvages are present.

This small bag was woven intentionally with one side patterned and the other side plain; it was completely planned as a single loomed cloth, even with the large creature woven upside-down. While bags such as this are often used to contain coca leaves during lifetime, this one may have subsequently accompanied its owner in death, attached to the outside of the mummy bundle during burial along with others used as offerings.

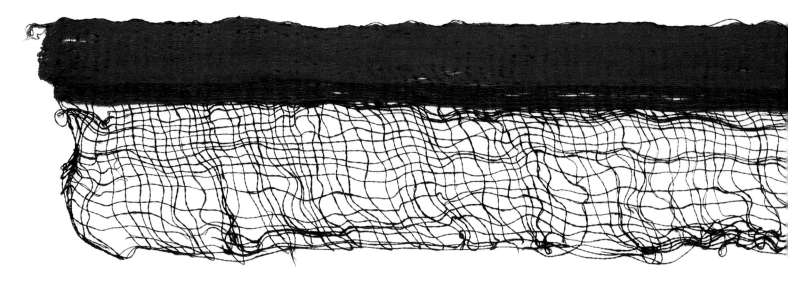

BELTS AND BANDS

Belts and bands are among the most complex of Andean weavings. They are created through braiding, looping, warp-patterned weaving, double- and triple-cloth, among other structures; moreover, sometimes these techniques are used in combination. Their colorful patterns extend along variable lengths, sometimes short, as for headbands (fig. 58), other times long—fifteen feet or more—when used as wrapping bands (fig. 57). Some bands have been found wrapped around the heads of mummies in burials. Others may have been used to tie and wrap precious bundles. As in other Andean weaving traditions, these bands have four selvages—though sometimes the final ends may have tassels and fringes. The uncut warp ends may be incorporated into the tassels. Nasca weavers from the south

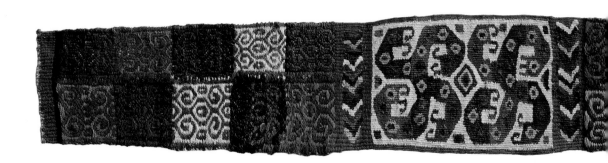

coast of Peru were especially adept at weaving narrow bands with multiple layers of cloth woven altogether (figs. 59a,b) These incorporated many colors and intricate patterns.

The long band with bird heads woven in blue, red, yellow, and white was constructed with four distinct layers (figs. 60a,b). The weaver's control of all these colors and yarns in the narrow tubular band is remarkable, as she worked her way row by row for this seventeen-foot length, not just three-layer triple-cloth, but four-layer quadruple-cloth. This means that each color had its full set of warps and wefts, binding separately, so that the red interlaces with red, the blue interlaces with blue, and so on, forming four individual layers of cloth that interweave with each other to form the design.

57
Head wrapping
Chancay culture, central coast of Peru
Late Intermediate/Late Horizon, circa 1200–1400 CE
Camelid hair; warp-faced and open plain weave
136 x 20 cm
FOWLER MUSEUM X72.554; GIFT OF LEO DRIMMER
NOT IN EXHIBITION

This long band, which was used as a burial head wrapping, is an unusual four-selvaged cloth that combines two types of weaving: solidly warp-faced weaving and a very open plain weave.

58
Headband
Wari culture, Nasca Valley, south coast of Peru
Middle Horizon, circa 600–1000 CE
Cotton warp, camelid hair weft; tapestry and weft-faced plain weave with complementary weft-float patterning
47 x 7 cm
FOWLER MUSEUM, X90.698; GIFT OF DORAN H. ROSS

Four selvages are present.

The hook-like motifs woven in the center of this headband are reminiscent of the abstract designs carved on the stone stelae from archaeological sites around Lake Titicaca, such as Atarco or Pucara. These sites are associated with early Yaya-Mama culture, the religious tradition of which preceded that of the highland Tiwanaku and Wari cultures. The designs, tightly woven in tapestry with areas of two-color geometric patterning, were likely intended to give protection to the wearer.

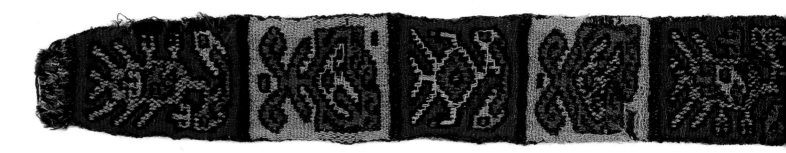

59A,B

Section of a woven band

Nasca culture, south coast of Peru

Early Intermediate Period, circa 200–500 CE (or later)

Camelid hair, dyed; balanced plain weave, quadruple-cloth (four layers)

49 x 5 cm

FOWLER MUSEUM X65.14508; GIFT OF THE WELLCOME TRUST

Three of the four selvage edges are present.

The small section of a band from the Nasca Valley is a complex weaving with stylized patterns of birds. It was likely used as a headband and was probably quite long. It is a quadruple-cloth with four distinctive woven layers: red, blue, yellow, and white. Each layer has its own warp and a weft, which only interlace according to color.

> Red (and also orange) warp binds with a red weft
>
> Blue warp (both light blue and dark blue) binds with a brown weft
>
> Yellow warp binds with a yellow weft.
>
> White warp binds with a white weft

Unlike the tubular band (see figs. 60a,b), each weft turns around at the outer edge to create the selvage edge of each layer of color. These layers are stitched together along the sides.

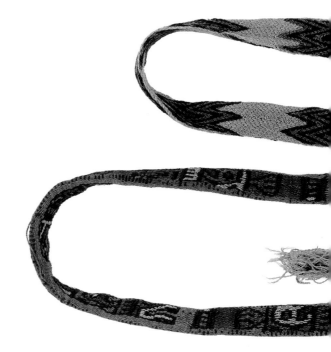

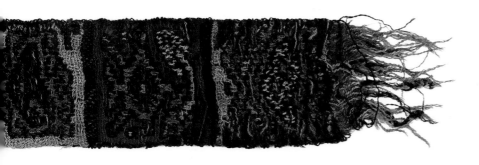

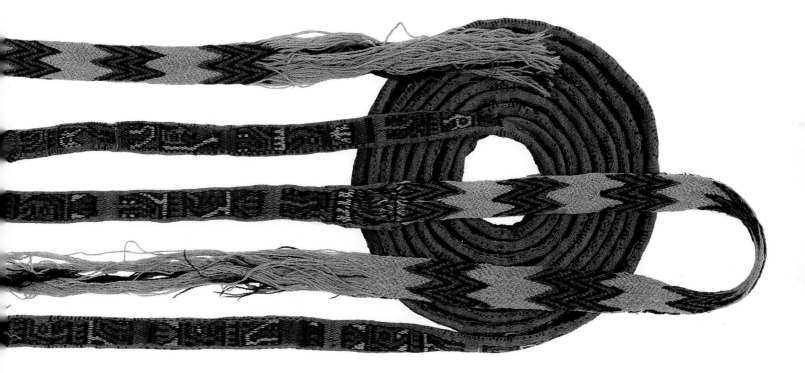

60A,B
Belt or head wrapping
Nasca culture, south coast of Peru
Early Intermediate Period, circa 200–500 CE
Camelid hair (Z spun, S plied), dyed, warp and weft; five color warp faced double-cloth, tubular weft with oblique interlacing
528 x 4 cm

FOWLER MUSEUM X65.11893; GIFT OF THE WELLCOME TRUST

Three components exist with all selvages.

This long narrow band or head wrapping with stylized bird designs is exquisitely woven in a warp-faced tubular double-cloth using five colors to create two distinct layers. The band, which is over seventeen-feet long, is strong and thick due to the number of colored warps carried in the center of the tube and used only when needed for the design. The selvage ends of the tubular band are attached to the chevron-designed oblique interlaced braids, which may have been more flexible for the final tying of the band around the head.

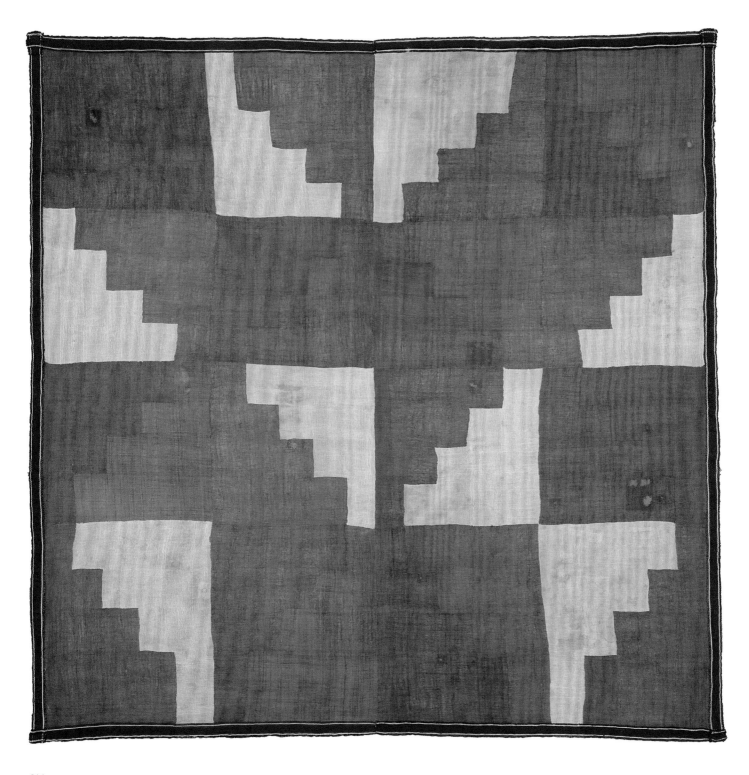

61A
Panel with stepped design
North coast of Peru
Late Intermediate Period, 1150–1450 CE
Camelid hair warp and weft (S-spun), some natural, some dyed colors; discontinuous warp and weft, plain weave with interlocking joins, warp-faced and warp-patterned edge bands (continuous and discontinuous)
146 x 145 cm

Two panels are stitched together. Each color section has finished edges; the piece as a whole is complete with all four outer selvages. Bands along the edges are also selvaged.

The simplicity of the design of this large panel belies the fact that it is a technical masterwork. Each finely spun cotton yarn connects to its adjacent color, forming a completely interlocked fabric of monochrome design units. The stepped design is a symbol seen throughout the coastal region of Peru in this time period. Whether it represents a pyramid or mountain or a more abstract concept is not known. The bright pink bands that surround the panel were woven at the same time, connected by common threads in the vertical direction, but stitched in the horizontal.

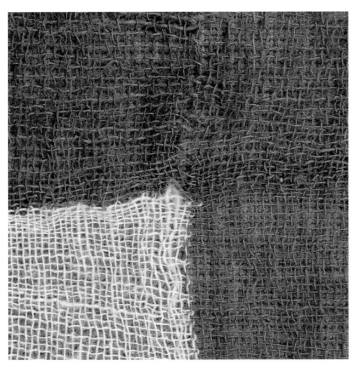

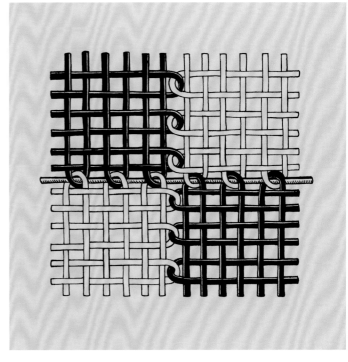

61B

The interlocking joins at the junctures of the colors along horizontal and vertical lines are visible in this detail of figure 61a. Along the horizontal axis, the scaffold weft is visible with each colored warp turning around, generally interlinking with the color below. Along the vertical axis, the colored yarns each interlink before they return to the next row.

61C

In the discontinuous warp and weft method scaffolding yarns are used to effect color changes. The hatched horizontal yarn is a scaffolding yarn still in place with the light and dark warps linked around it; after weaving, the scaffolding yarn would be removed. In the vertical direction, a scaffolding yarn may or may not have been used. DRAWING BY CHRISTIAN D. JACOBS.

DISCONTINUOUS WARP AND WEFT

A very special Andean weaving tradition, referred to as discontinuous warp and weft weaving, creates pure color areas where each is formed with its own threads of particular colors and with defined perimeters, forming a kind of selvaged unit within the larger cloth (figs. 61a-c). This is generally achieved by using special scaffolding sticks or cords to hold the warp yarns in place and positioned at each point where the color changes, often in a gridded arrangement. Sometimes, for very special textiles designed with fluid and nonlinear designs, rather than aligning color changes along a grid, other methods were used. We do not know, for example, exactly how the master Nasca weavers created their spectacular textiles, such as the most famous example in the Brooklyn Museum, though certainly it must have been done with a combination of scaffolds, needles and some other additional supports for the numerous color changes (figs. 62, 63a,b). Only in Peru was this technique utilized to create complex designs: each color area independently created with its own warp and weft. Used for ceremonial and ritual hangings as well as a number of special garments, this method of weaving with pure color areas was a remarkable feat, extremely time consuming and technically difficult all with the purpose to compose designs with an integrity of color in warp and weft. Why was this so important to the Andean people? The answer is uncertain but it appears to represent a cultural value system that, like creating a complete, four-selvaged cloth, reveres completeness and integrity of the cloth (figs. 64–66).

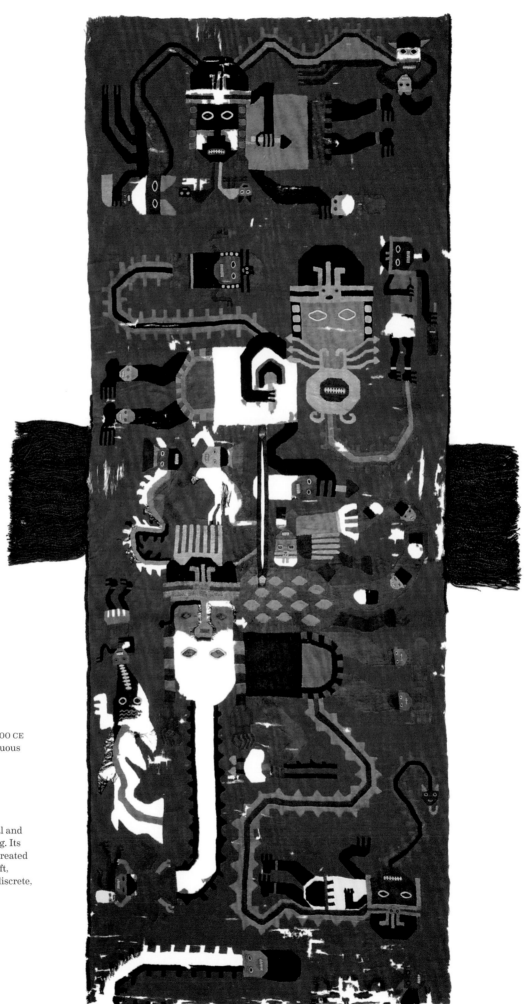

62
Panel (remade into a tunic)
Nasca culture, Nasca Valley,
Peru
Early Intermediate Period, circa 100–200 CE
Camelid-hair warp and weft; discontinuous
warp and weft, plain weave
189 x 70 cm
BROOKLYN MUSEUM, NO. 34.1579;
ALFRED W. JENKINS FUND
NOT IN EXHIBITION

This extraordinary textile is a technical and
artistic masterpiece of Andean weaving. Its
large-scale supernatural figures were created
entirely of discontinuous warp and weft,
where each colored detail is formed of discrete,
selvaged units

63A,B
Fragment from a tunic
Nasca/Wari culture, likely from the Nasca Valley, south coast of Peru
600–800 CE
Camelid hair warp and weft (Z-spun, S-plied); woven, tie-dyed and reassembled
170 x 35 cm
FOWLER MUSEUM X86.3953; GIFT OF MR. AND MRS. HERBERT L. LUCAS JR.

Each section is composed of discontinuous warp and weft—as complete units.
All selvages are preserved, including on the warp-fringed edges top and bottom.

These complex tie-dyed elements were part of a spectacular tunic and
represent a tradition that developed in the south coast of Peru in a period
associated with the Wari cultural presence in the region. A number of these
types of colorful and dazzling textiles have been preserved. Here we see a
fragment, which represents almost the complete length of a tunic, including
the fringed edges. The tunic would have been formed by folding the textile
at the shoulder line and stitching the side seams together. The composition
is the result of a number of steps: woven in narrow strips, the shapes of
each rectangular component were formed through discontinuous warps
and wefts, separated with a scaffolding yarn that could be removed after the
weaving was completed. The strips were dyed in a number of different resist
or tie-dye patterns and in different dye baths, and then separated into their
components and assembled in a different order. The rectangular shapes
were joined together by reinserting a scaffolding yarn to join sections in one
direction, and by stitching in the other, forming what appears to be an undu-
lating stepped design. Unlike the smaller example below (see fig. 65), this
design is formed visually rather than technically. By offsetting the colored
rectangles, and placing them adjacent to secondary rectangles, the illusion
of the colors forming a continuous stepped pattern emerges, when in fact
this is constructed with separate rectangular units.

64

Tunic

Late Nasca culture, south coast of Peru

Middle Horizon, 600–1000 CE

Camelid-hair warp and weft (Z-spun, S-plied) with interlocked and
dovetailed joins; discontinuous warp and weft (warp-predominant);
woven added fringe

128 x 126 cm

FOWLER MUSEUM X82.1030: GIFT OF NANCY R. PITT

NOT IN EXHIBITION

Each of the two panels has all four selvages (in addition to the complete color sections).

Dazzling zigzag designs in mismatched panels make up the tunic. The sides
are stitched together with an area left open for the arms and neck. Woven
with discontinuous warps and wefts, the bold monochrome color blocks
creating the design were interconnected to one another through a scaffolding
system that aided the color changes during the weaving process. The color
palette and technique are typical of the south coast of Peru, and this large
garment would have been part of a burial.

65
Fragment from a tie-dyed mantle
Nasca/Wari culture, Nasca Valley, south coast of Peru
Circa 600–700 CE
Camelid-hair warp and weft, resist dyed (tie-dyed); discontinuous warp and weft, plain weave
15 x 7 cm

FOWLER MUSEUM X80.1122; GIFT OF DORAN H. ROSS

Ten selvage edges are present on this fragment.

Composed as a stepped design, this small tie-dyed textile (woven to shape) is a near-complete unit. It would have formed one part of a puzzle-like composition (see fig. 64). The cloth would have been woven, removed from the loom, tied with a material that would resist the penetration of dye, and then immersed in a red dye bath (likely made from a madder-like plant). After removal from the dye bath, the resist material would have been removed, revealing the original white color of the woven camelid-hair cloth. Each edge of the stepped pattern was created with discontinuous warps and wefts, set up on the loom with scaffolding yarns.

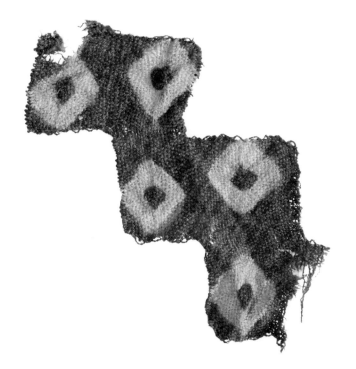

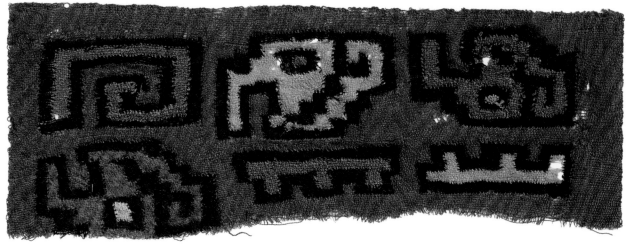

66
Fragment with stepped bird and scroll design
Nasca culture, south coast of Peru
Early Intermediate Period (Late Nasca), 500–700 CE
Polychrome-dyed camelid-hair warp and weft (Z-spun, S-plied); discontinuous warp and weft, balanced plain weave
41 x 15 cm

FOWLER MUSEUM X65.8727; GIFT OF THE WELLCOME TRUST

All color areas have distinct edges. The fragment has all four selvages preserved.

This small unit is woven in discontinuous warp and weft. The curvilinear designs of the bird's head together with the step and wave pattern—often seen in textiles from the south coast of this period—follow the grid format of the woven cloth. This was perhaps a practice piece made so the artisan could understand how to construct such a complex weaving where each area, including the dark outline composed of only two threads, has its own set of warps and wefts in the appropriate colors: cochineal red, indigo blue, yellow-brown, and white.

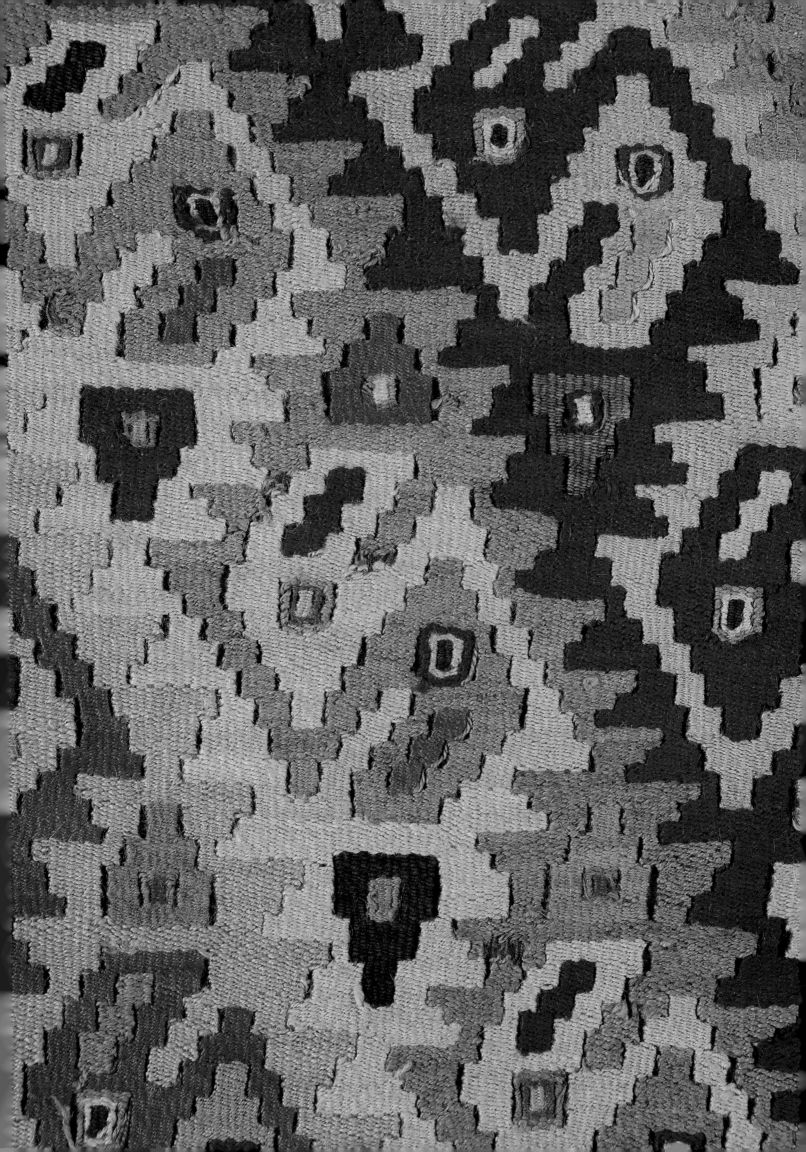

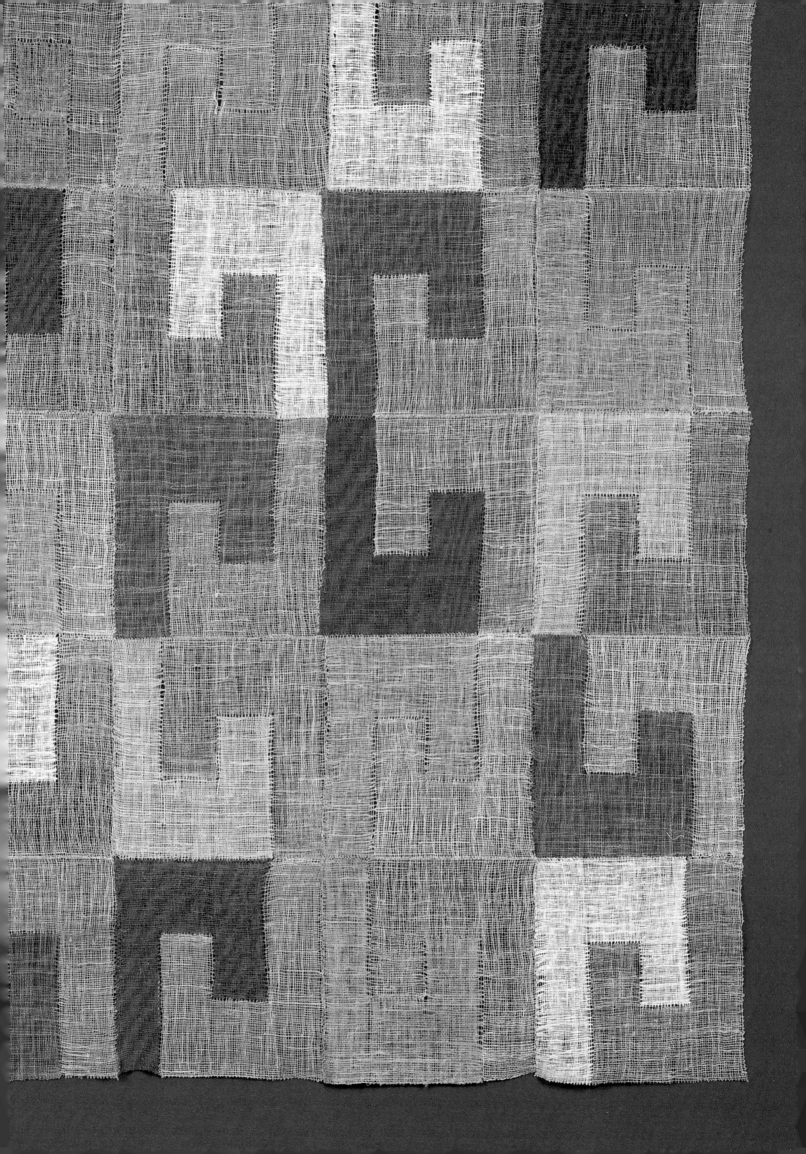

PART TWO *New Directions:* The Four-Selvaged Cloth Today

Arriving in Peru in the early sixteenth century, the Spanish were awestruck by the beauty and ingenuity of the textiles that they saw there. Through their reports and through the books, drawings, and examples later sent back to Europe—by priests such as Diego de Ocaña (circa 1570–1608) and Jaime Baltazar Martínez Compañón (1737–1797), travelers like the French engineer Amédée-François Frézier (1682–1773), and the many treasure hunters and others who visited during the seventeenth through the nineteenth century—the existence of this refined tradition gradually became known outside of the Andean world, although in a limited way. In the early part of the twentieth century, however, a trove of archaeological treasures was discovered that would forever change our understanding of the textile arts of Peru. In 1927 Julio C. Tello excavated 429 mummies in the Cerro Colorado of the Paracas Peninsula.[6] These elite mummies were each wrapped in layer-upon-layer of elaborately woven and embroidered cloth.

French ethnologist Raoul d'Harcourt authored an early publication celebrating and analyzing these newly excavated textiles and other Andean examples, *Les textiles anciens du Pérou et leurs techniques* (Textiles of ancient Peru and their techniques; 1934).[7] In his study, which was aimed at a specialist audience, d'Harcourt sought to "describe in detail all the ancient techniques." His book, translated into English in 1962 with multiple reprintings, is still used today as one of the primary sources for learning about these processes.[8] From the 1940s to 1970s Junius Bird, an archaeologist based at the American Museum of Natural History in New York, furthered the excavation of Peruvian textiles and the study of the techniques used to create them. Bird fully recognized the importance of the textile arts within the context of ancient Peruvian civilization, and through his own work and his encouragement of students and other scholars, he became a virtual ambassador to the field of Andean textile studies.[9]

Three contemporary artists—Sheila Hicks, John Cohen, and Jim Bassler—have been drawn to and profoundly influenced by Andean textiles, and they have also been inspired by the scholarship of d'Harcourt and Bird. Sheila Hicks and John Cohen both studied art at Yale University in the 1950s (although they did not know each other), and each had direct contact with Bird, who encouraged their separate investigations; and Jim Bassler has acknowledged d'Harcourt's publication as inspiration for his own lifelong study. Each of the three artists developed a unique and abiding interest in the substance and meaning of the Andean four-selvaged cloth tradition, and the fascination remains a strong current in their respective creative processes today.

·············

Sheila Hicks, attended Yale in the 1950s attaining a BFA degree in 1957 and an MFA in 1959—both in painting. At Yale, she studied with Josef Albers and George Kubler. A noted scholar of Latin American art and architecture, Kubler introduced Hicks to Andean textiles in his art history class in 1956. She subsequently wrote an essay on the subject and developed it further for her BFA thesis. "Kubler sent me to Junius," Hicks remarked recently, and "concurrently, during the summer of 1956 I was given access to the storeroom at the Chicago Art Institute by Alan Sawyer, curator there at the time. He allowed me to photograph and inspect their holdings. That is where I connected with the material intimately."[10]

As a Fulbright Scholar in 1957–1958, Hicks traveled to South America and began collecting ancient textile fragments. She also observed women preparing fibers, spinning, and weaving using a wide variety of techniques on different types of looms. Subsequently she lived briefly in Chile and Mexico, settling in France in 1964. She has since gained international renown as a fiber artist and has traveled widely through Germany, Morocco, Israel, Japan, Saudi Arabia, South Africa, and elsewhere—often creating site-specific, large-scale works that engage with their architectural surroundings. Beginning in the 1950s, however, and throughout all of her travels, she has kept with her a small frame with tiny nails used to hold warp threads. With this makeshift loom, she developed a process for creating small four-selvaged cloth works that she refers to as her *minimes* (fig. 67). These works form the core of her artistic vision, each reflecting a particular moment in time or a place. As she has noted, "My textile vocabulary is composed of structure. My art vocabulary is composed of color and form inextricably linked."[11]

While Hicks may be best known for her internationally exhibited, large-scale works, her miniature weavings—each a universe unto itself—constitute an ongoing and personal artistic investigation. In recent years, these small works have been exhibited in New York, São Paulo (at the 2012 Biennale), and various European venues.[12] Creating weave structures using her fingers, needles, and simple sticks as her tools (fig. 68), Hicks incorporates into these artworks the materials she finds around her, including silk threads and shoelaces, linen cords and starched collars, handspun alpaca, cotton, paper (fig. 69), stainless steel, synthetics, flea market finds, and industrial supplies. Pieces such as *Escribiendo con textura* (Writing with texture; fig. 70), *Cicatrices* (fig. 71), and *Fentes Lignerolles* (Slits, Lignerolles [France]; fig. 72) seem to record almost visceral reactions; while others appear to capture dialogue (fig. 73), rejoice in shades of a single color (fig. 74), honor the majesty of an Inca king (fig. 75), reflect the joys of nature (fig. 76), document discord (fig. 77), examine the expressive possibilities of a thread (fig. 78), or depict the essence of simplicity (fig. 79). All are created as complete units of four-selvaged cloth that encapsulate and express her conceptual process and internal dialogues.

·············

Detail of figure 86.

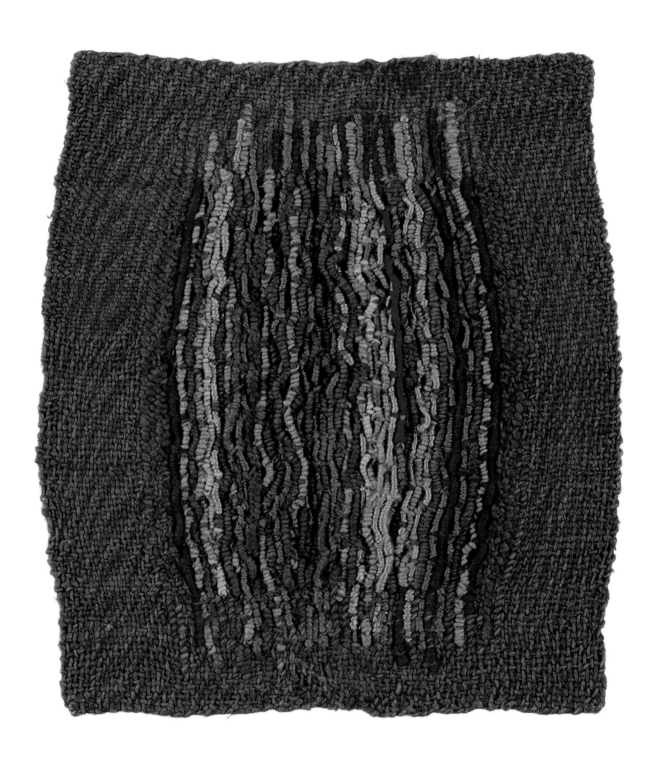

67
Sheila Hicks (b. Hastings, Nebraska, 1934)
Squiggle, 1963
Silk; woven and embroidered, reversible, four-selvaged
28 x 24 cm

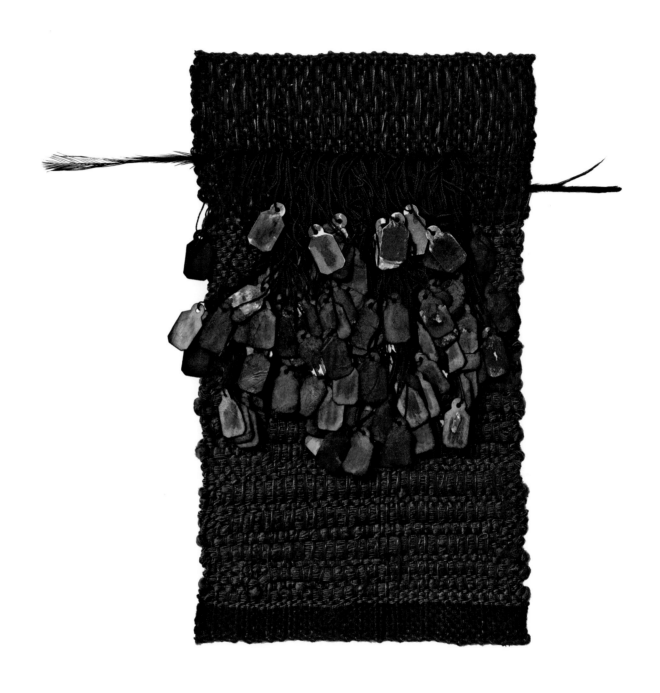

68
Sheila Hicks (b. Hastings, Nebraska, 1934)
Mauresque étiquette (Moorish etiquette), 2013
Cotton, silk paper, feather; woven, four-selvaged
24 x 14 cm
COURTESY OF THE ARTIST
PHOTOGRAPH BY MICHAEL BRZEZINSKI

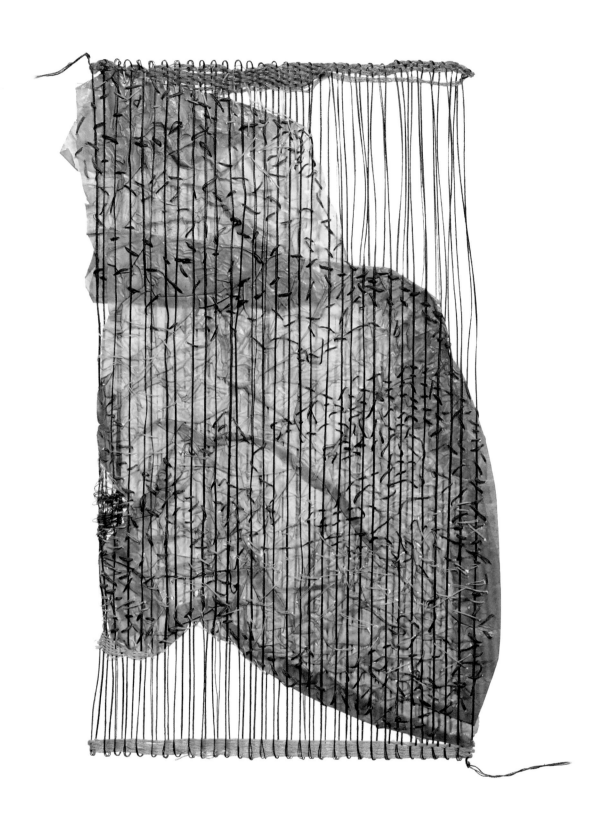

69
Sheila Hicks (b. Hastings, Nebraska, 1934)
Papillon, 1997–2004
Synthetic fiber, color transfer paper; dyed, woven, sewn, four-selvaged
28 x 18 cm

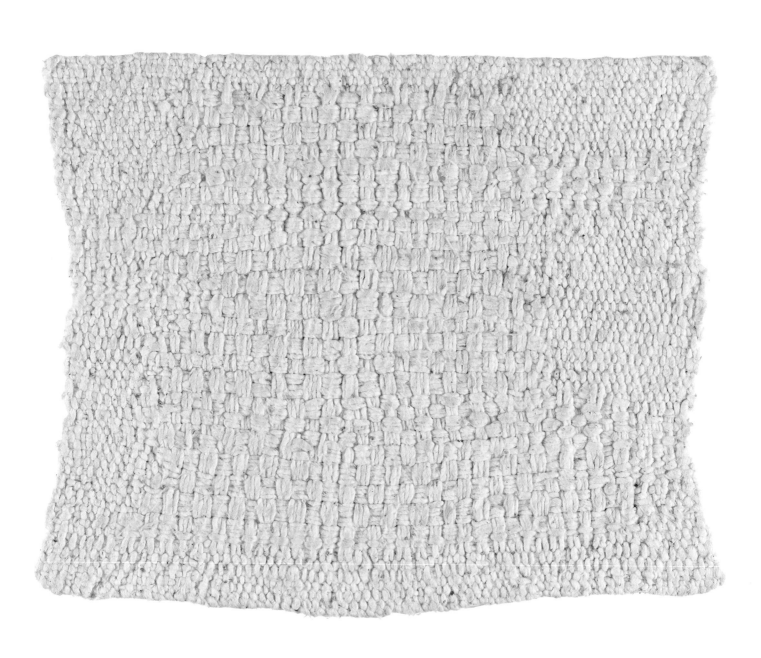

70
Sheila Hicks (b. Hastings, Nebraska, 1934)
Escribiendo con textura (Writing with texture), 1960
Unbleached cotton; plain weave, warps and wefts grouped in center area,
reversible, four-selvaged
27 x 33 cm

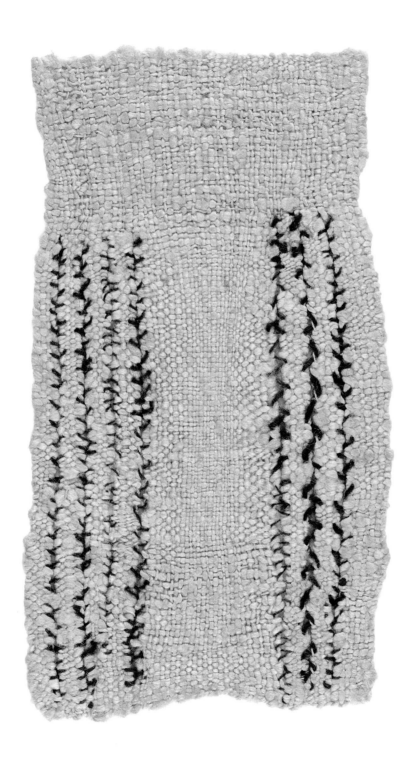

71
Sheila Hicks (b. Hastings, Nebraska, 1934)
Cicatrices, 1968
Silk, mohair; woven, embroidered, four-selvaged
21 x 12 cm

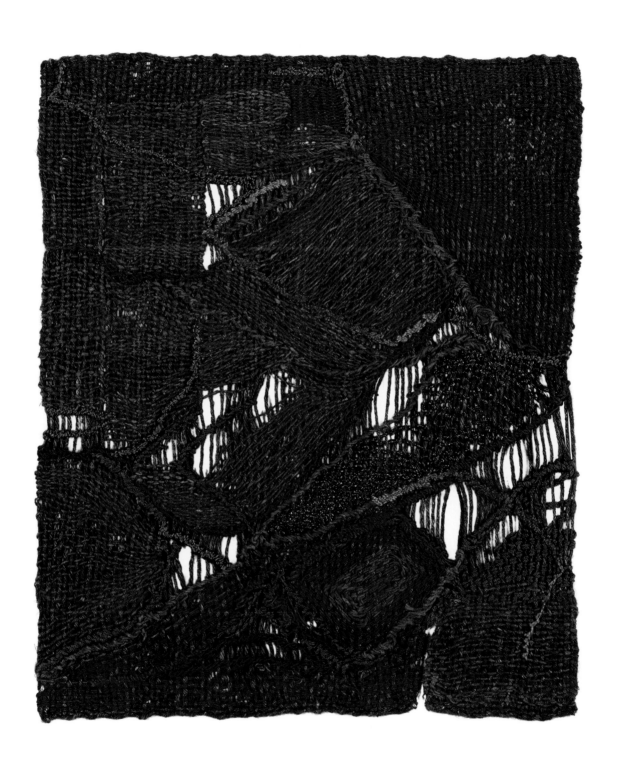

72
Sheila Hicks (b. Hastings, Nebraska, 1934)
Fentes Lignerolles (Slits, Lignerolles [France]), 2010
Hemp, linen, cotton, bamboo, metallic thread; woven, wrapped,
embroidered, four-selvaged
23 x 15 cm
COURTESY OF THE ARTIST AND SIKKEMA JENKINS & CO., NY
PHOTOGRAPH BY JASON WYCHE

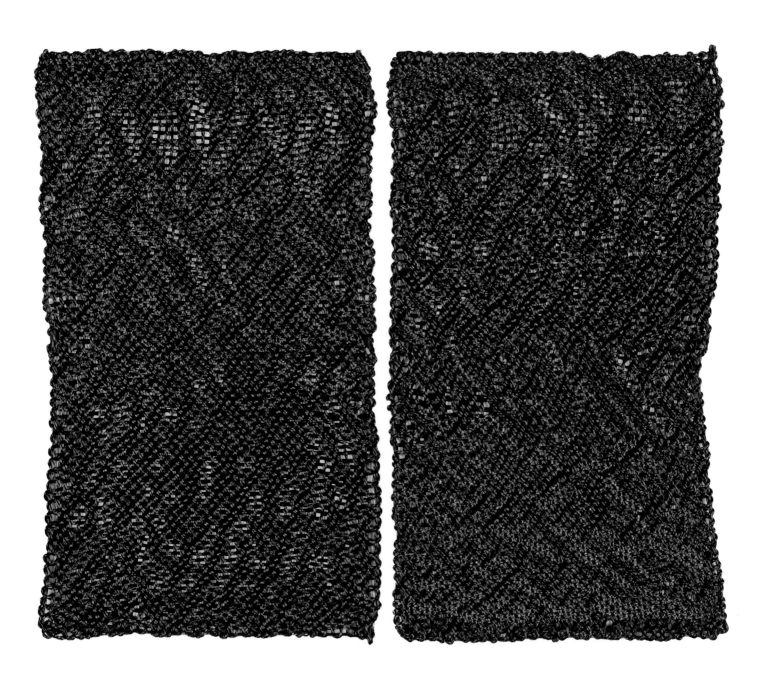

73
Sheila Hicks (b. Hastings, Nebraska, 1934)
Rapprochement, circa 1998
Stainless steel fiber; woven, four-selvaged
24 x 15 cm (each panel)
COOPER-HEWITT, NATIONAL DESIGN MUSEUM, SMITHSONIAN INSTITUTION, NEW YORK,
NO. 2006-13-9A,B; MUSEUM PURCHASE FROM GENERAL ACQUISITIONS ENDOWMENT FUND
PHOTOGRAPH BY MATT FLYNN © SMITHSONIAN INSTITUTION
ART RESOURCE, NY

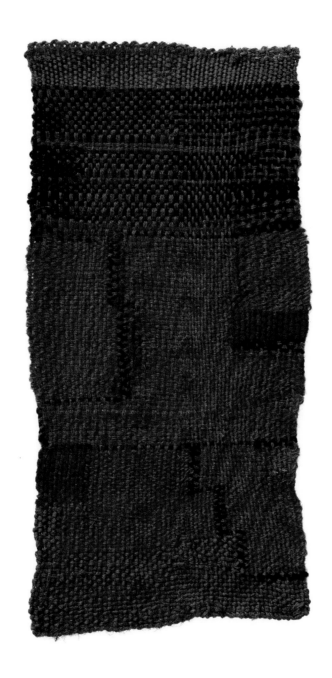

74
Sheila Hicks (b. Hastings, Nebraska, 1934)
Violet, Cochineal, Bougainvillea, 1983
Wool; woven, four-selvaged
25 x 13 cm
PRIVATE COLLECTION

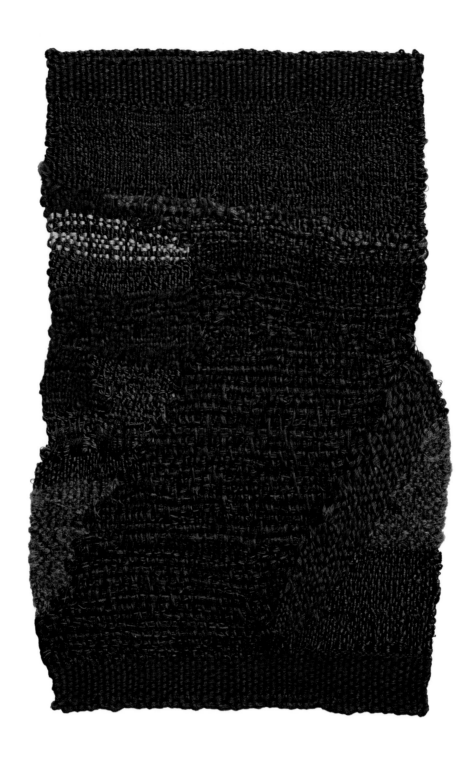

75
Sheila Hicks (b. Hastings, Nebraska, 1934)
Passage of Atahualpa, 2008
Wool, cotton, silk; woven, four-selvaged
24 x 20 cm
COURTESY OF THE ARTIST AND SIKKEMA JENKINS & CO., NY

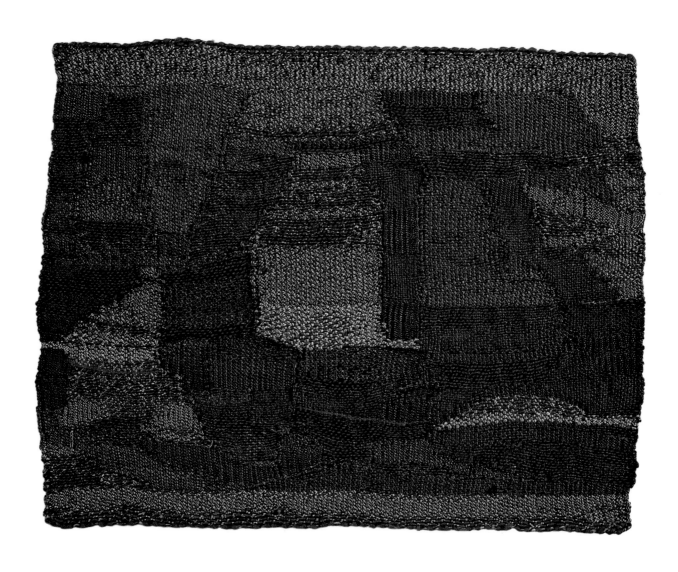

76
Sheila Hicks (b. Hastings, Nebraska, 1934)
Night Bird's Song, 1997
Spun stainless steel threads; plain weave with weft slits, four-selvaged
15 x 25 cm
ANONYMOUS LENDER

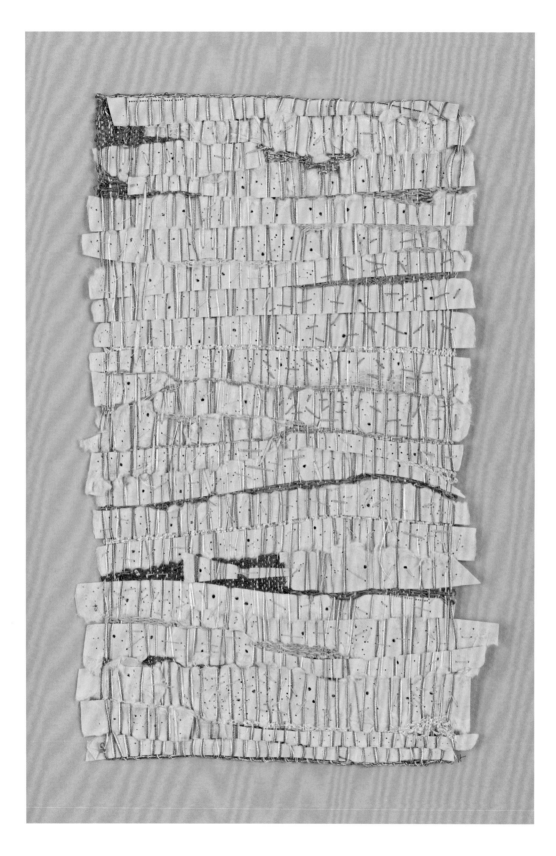

77
Sheila Hicks (b. Hastings, Nebraska, 1934)
La lettre de rupture (Break-up letter), 2004
Cotton, handmade paper, linen; woven, four-selvaged
25 x 15 cm
PRIVATE COLLECTION

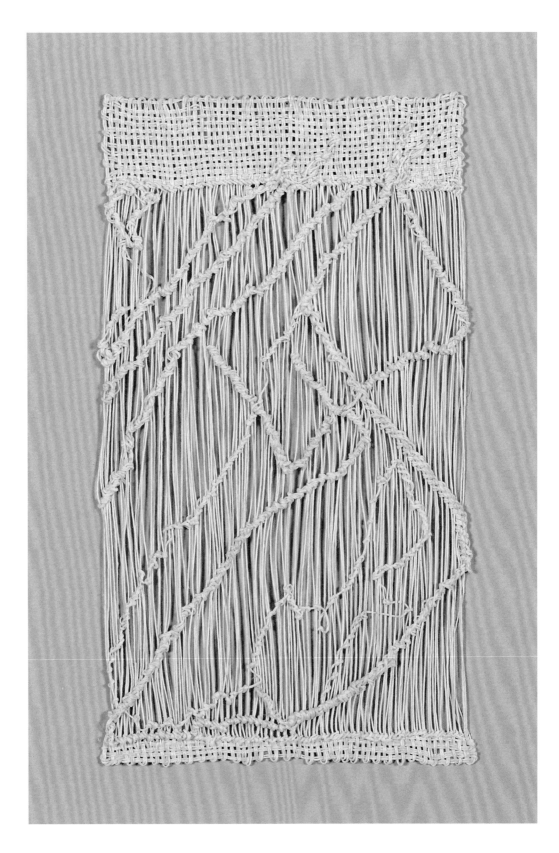

78
Sheila Hicks (b. Hastings, Nebraska, 1934)
Conversation between Friends, 1988
Linen; woven, wrapped, four-selvaged
23 x 15 cm
COURTESY OF THE ARTIST AND SIKKEMA JENKINS & CO., NY
PHOTOGRAPH BY JASON WYCHE

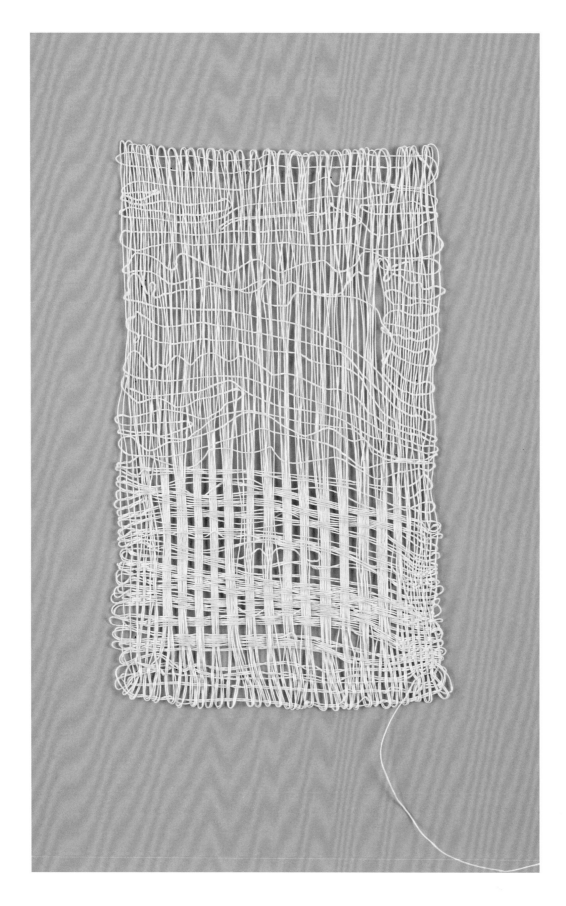

79
Sheila Hicks (b. Hastings, Nebraska, 1934)
Loosely Speaking, 1988
Linen; woven, four-selvaged
25 x 15 cm
COURTESY OF ANDREA SCHWAN, NY

While at Yale in 1956 John Cohen pursued his interest in ethnomusicology but also studied painting with Josef Albers. His studies eventually led him to Junius Bird, who in turn encouraged him to visit the highlands of Peru. Traveling in the mid-1950s, Cohen documented rural life in the harsh climates of the coastal deserts and highland valleys (fig. 81). Fascinated by the weaving he observed in each area, he photographed and recorded each step of the process: the herding of animals, the spinning and plying of yarns (see fig. 20), the laying out of the warp thread-by-thread, the setting up of the loom (see figs. 30, 37), and the intricate processes that followed (see fig. 34). For his Master's thesis at Yale, Cohen sought "connections of ethnographic textiles with textiles of the distant past."[13] He was amazed by the Paracas textiles at the Brooklyn Museum (see figs. 62, 85) and wanted to understand the relationships between these ancient treasures and the textile traditions that continued to thrive in the Andes.

Cohen collected information based on a questionnaire that Junius Bird had shared with him, which included detailed inquiries concerning spinning, warping, dyeing, and weaving. It also addressed the rules and rhythms of the process, how yarns were handled, what types of resist dyeing methods were used, the components of the loom, how the threads were separated, and so forth.[14] Cohen's photographs give us intimate views of weavers meticulously passing threads through the warp (fig. 80), the laborious yarn-by-yarn preparation of a loom, the spinner's fingers holding and pulling fluffy wool fibers to maintain the uniformity of spun yarn (see fig. 20). The recording of these techniques and of the women who so deftly and expertly executed them is clearly established amidst the harsh environs. Cohen's photographs convey the deeply embedded meaning of textile production to the weavers and to the peoples of the Andes as a whole, as well as his sensitivity to his subjects.

On subsequent trips Cohen filmed these processes, capturing again, not only the technical process of weaving but also the spirit and culture of the Andean people (fig. 82).[15] His films and photographs also stress how the weavers transmit their knowledge through generations. This is epitomized in an image where a mother weaves on a backstrap loom, as a young child beside her spins the yarn, and a baby plays with and teases the fibers, gaining familiarity with an essential aspect of Andean life (fig. 84). Like Jim Bassler (see below), Cohen is particularly fascinated by the weaving of discontinuous warp textiles (fig. 83). His film recordings and photographs remain some of the best documentation of this process to this day and are relied upon by scholars and appreciated as well by a wider audience.

············

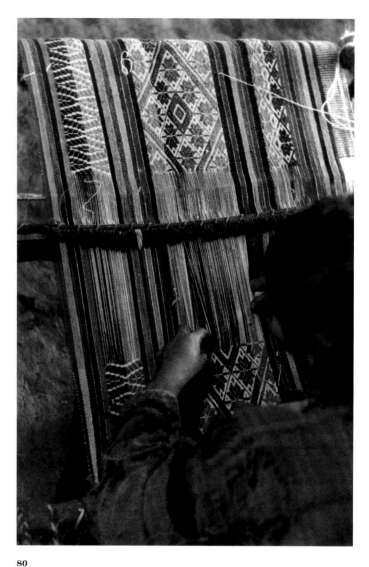

80
John Cohen (b. New York, New York, 1932)
"Weaving from both ends of the loom (near Ocongate)"
Mid-1950s
Black and white photograph

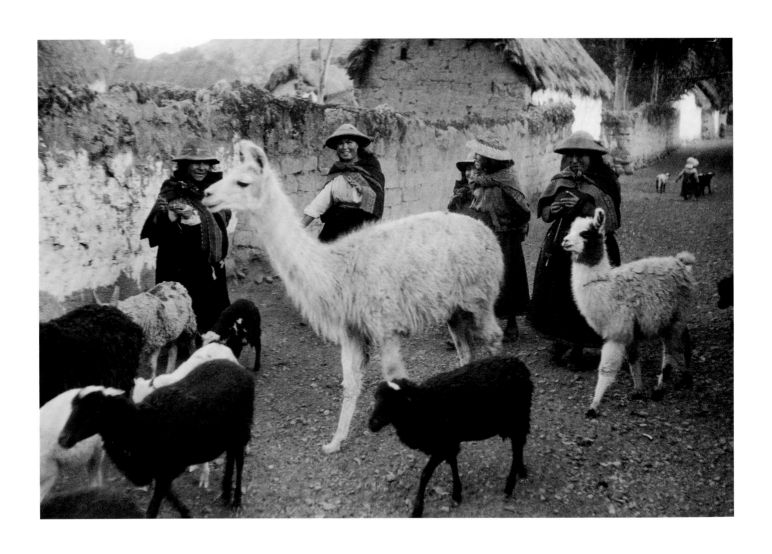

81
John Cohen (b. New York, New York, 1932)
Women Walking with Flock Spinning, near Pisac, 1956
Gelatin silver print, printed 2013
28 x 36 cm
COPYRIGHT JOHN COHEN, COURTESY L. PARKER STEPHENSON PHOTOGRAPHS, NY

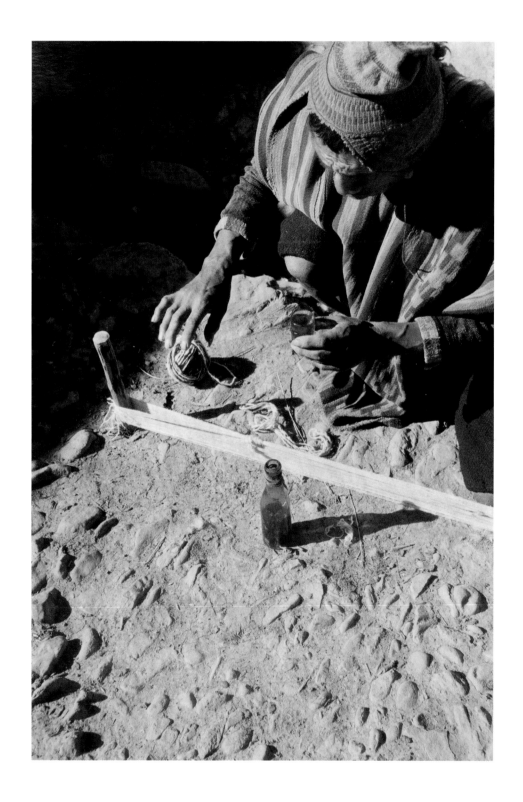

82
John Cohen (b. New York, New York, 1932)
Blessing the Warp, Ccatcca, 1956
Gelatin silver print, printed 2013
36 x 28 cm

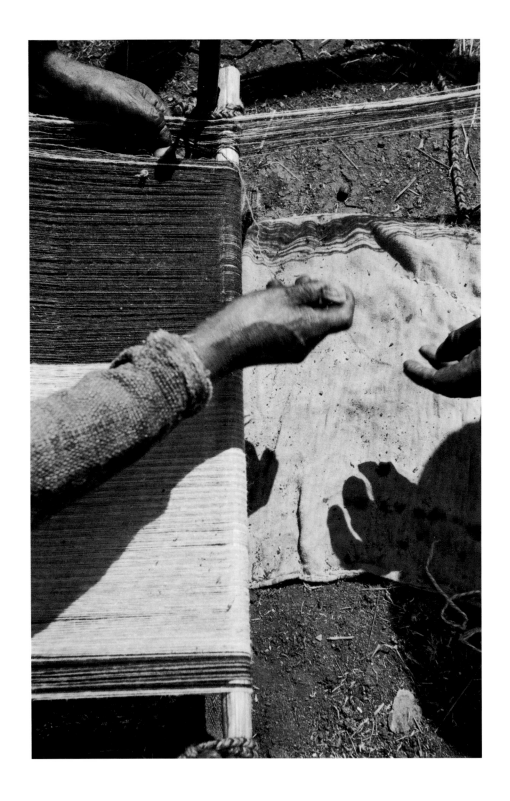

83
John Cohen (b. New York, New York, 1932)
Loom for Discontinuous Warp, 1977
Gelatin silver print, printed 2013
36 x 28 cm

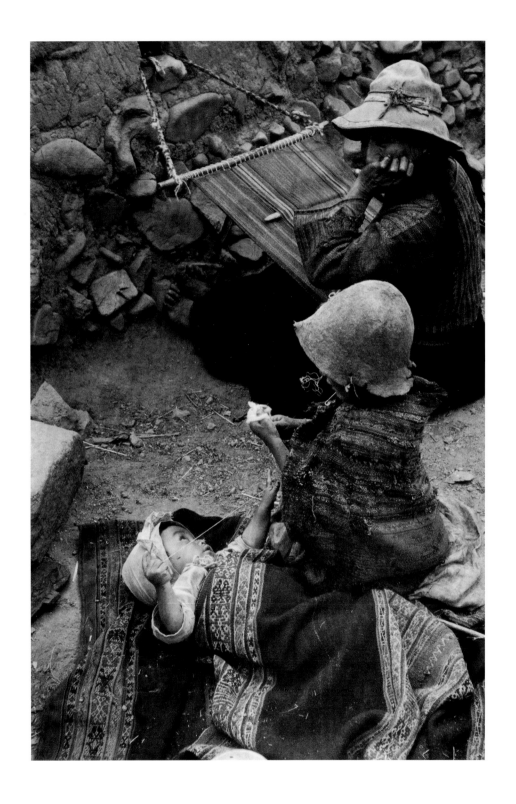

84
John Cohen (b. New York, New York, 1932)
Mother Watching Her Children Play with Wool, near Pisac, 1956–1957
Gelatin silver print, printed 2013
36 x 28 cm

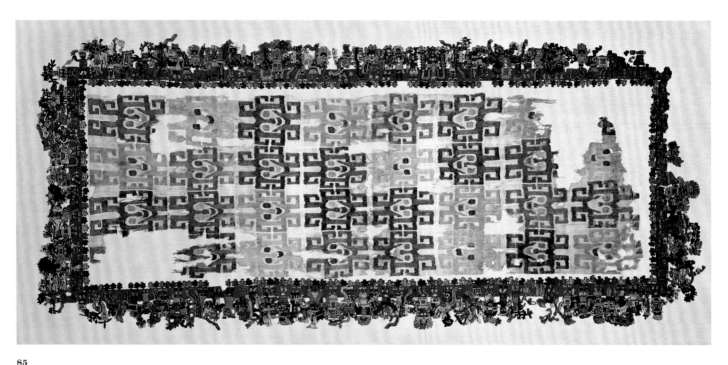

85

Mantle

Nasca culture, Paracas Peninsula, south coast of Peru

Early Intermediate Period, 100–300 CE

Cotton, camelid fiber; warp-wrapped plain weave and three-dimensional
cross-looped borders.

62 x 148 cm

This celebrated cloth, known as the "Paracas Textile," was made famous by
French ethnologist Raoul d'Harcourt with his detailed photographs of the
animated border.

Jim Bassler recounts that while serving in the Army in the 1950s,
he had a twenty-four-hour layover in New Jersey.[16] He used this
opportunity to make a beeline to the Brooklyn Museum to see
the "Paracas Textile" made famous by d'Harcourt (fig. 85). The
memory of the textiles he saw in Brooklyn and the technical
puzzle they presented stayed with him through his subsequent
pursuits, including the eighteen years he spent teaching design
at UCLA.

An accomplished artist equipped with an engineer's mindset,
Bassler developed his own modern techniques to work through
and understand Andean weaving processes. During his visit
to the Brooklyn Museum, one of the most remarkable extant
examples of a textile made with discontinuous warp and weft
techniques especially intrigued him (see fig. 62). Bassler was
fascinated with this intricate process, which would inform a
large body of his work beginning in the mid-1990s. Painstakingly
pinning out each thread for each color section on sheets of
foamcore, he produced his own complex and beautiful four-
selvaged works (fig. 86). Some were inspired by the bold designs
and structures of ancient Peruvian textiles that Bassler had the
opportunity to examine closely at the Fowler Museum and the
Los Angeles County Museum of Art (fig. 87). The impact that
these pieces had on him is reflected in his work and amounts to
an acknowledgment of the prowess of ancient weavers, but their
gifts have been interpreted through Bassler's own perspective

in a modern context (fig. 88). His works, crafted in his own
unique and transformative language of color, design, and tex-
ture, carry with them the knowledge of the past brought into
a vastly changed present. While beautiful, Bassler's weavings
can also exude a strong sense of whimsy and engage in social
commentary. This is the case with the bag that he wove essen-
tially from itself—constructing weaving elements from twisted
strands of the commercially made paper bags for Trader Joe's
(a much-loved institution originating in California; fig. 89).
Owning and transforming the artistic process, he has developed
his methodology creating two- and -three-dimensional works
of great integrity and wholeness. Inspired and respectful of the
technical facility of Andean weavers, Jim's lifelong love of the
art and process of weaving, and particularly of the four-selvaged
cloth, has led to a very personal vision (fig. 90, and see fig. 87).

············

These three artists have spent years engaged in the exploration,
investigation, and creation of four-selvaged cloths. Like the
anonymous Andean weavers whose art and process created
culturally meaningful works of power and beauty, Hicks,
Cohen, and Bassler have communicated their own artistic
vision through a type of weaving that engages in a deliberate
and physical act of intent.

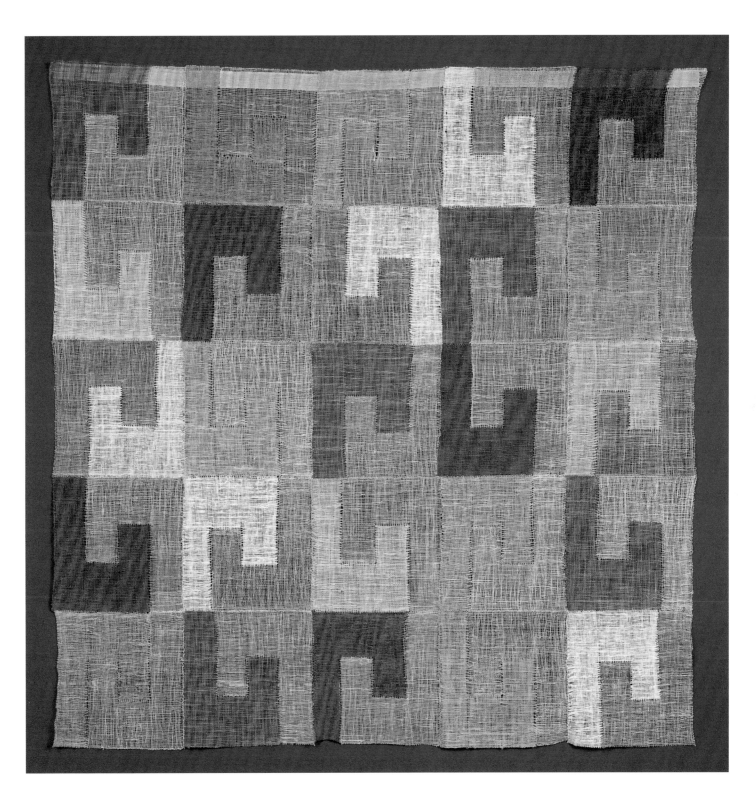

86
James Bassler (b. Santa Monica, California, 1933)
"L," 2007
Linen, nettles; woven, discontinuous warp and weft, all-selvaged
122 x 122 cm
ANONYMOUS LENDER

87
James Bassler (b. Santa Monica, California, 1933)
Thank You Wari, 2012
Linen, natural brown cotton, alpaca, silk; cochineal, indigo, and marigold
dyes; tie-dye and blue print/silkscreen discharge; woven, discontinuous
warp and weft, all-selvaged
65 x 68 cm
COURTESY OF GAIL MARTIN GALLERY, NY

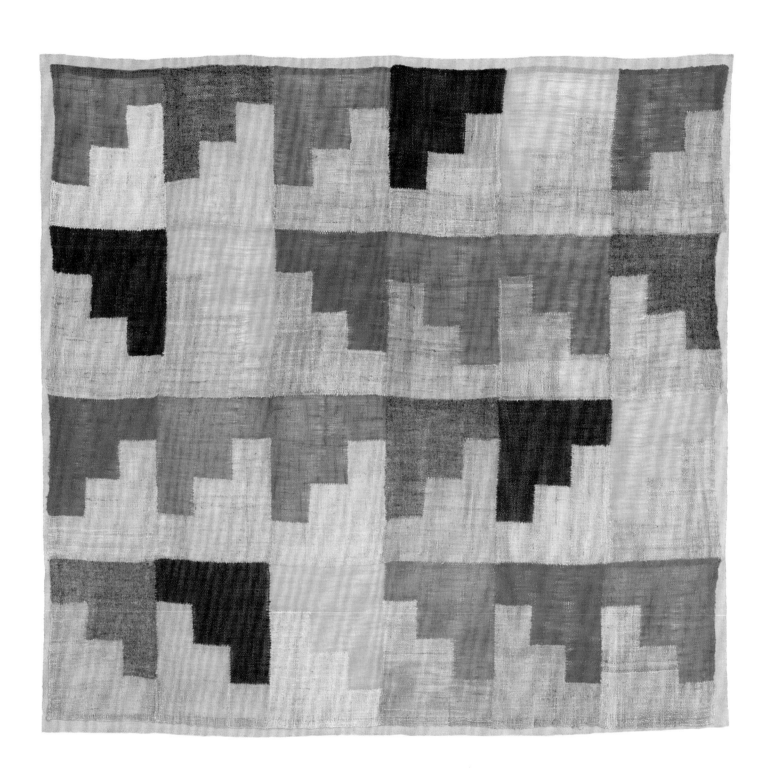

88
James Bassler (b. Santa Monica, California, 1933)
Six x Four II, 2009
Hemp, cochineal-dyed alpaca, natural brown cotton, natural alpaca; woven,
discontinuous warp and weft, all-selvaged
117 x 123 cm
COURTESY OF GAIL MARTIN GALLERY, NY

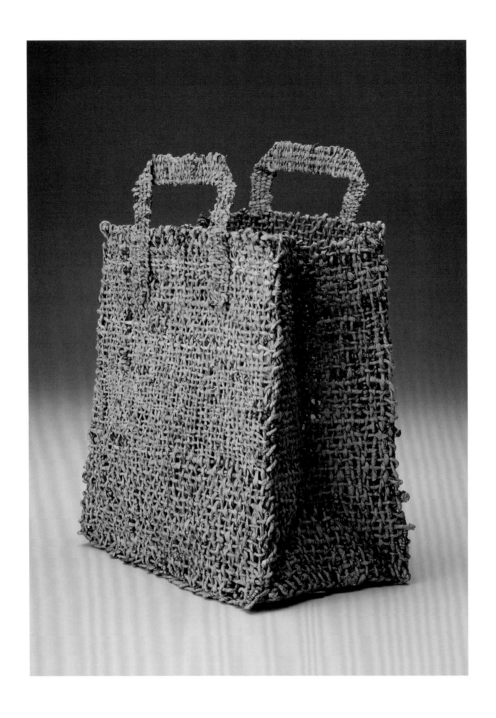

89
James Bassler (b. Santa Monica, California, 1933)
Shop (Trader Joe's Bag), 2009
Twisted paper, silk; woven, embroidered, all-selvaged
61 x 61 cm
COURTESY OF GAIL MARTIN GALLERY, NY

90
James Bassler (b. Santa Monica, California, 1933)
Another Weaving, 2013
Linen, silk, cotton, bamboo, nettles; woven, wedge weave, tapestry
132 x 112 cm
COLLECTION OF THE ARTIST
PHOTOGRAPH BY MARK DAVIDSON

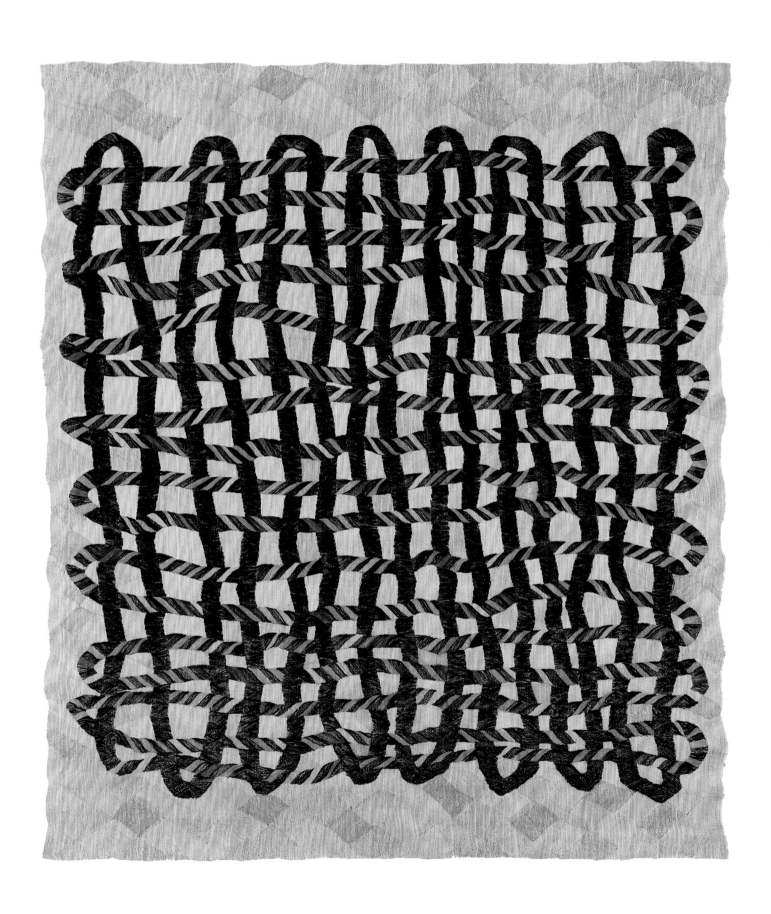

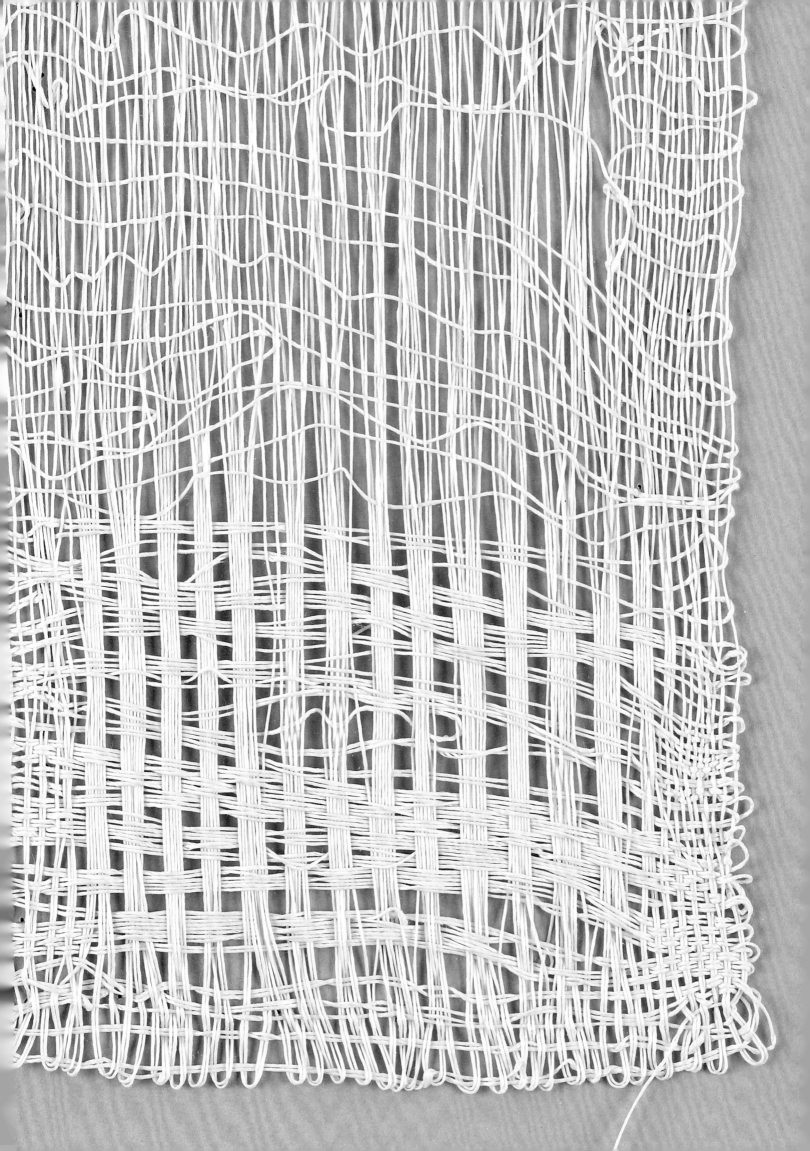

Notes to the Text

1. Garcilaso de la Vega [El Inca], *Royal Commentaries of the Incas and General History of Peru*, trans. and ed. Harold V. Livermore, 2 vols. (Austin: University of Texas Press, [1609] 1966). The epigraph is from [1609] 1966, bk 4, ch 13, 214.
2. Richard Burger, *Chavin and the Origins of Andean Civilization* (New York: Thames and Hudson, 1992).
3. Bruce Mannheim, *The Language of the Inka since the European Invasion* (Austin: University of Texas Press, 1991), 50. For further information, see Santa Cruz Pachacuti Yamqui, *Relacion de antiguedades desde reyno del Pirú*, transcription and facsimile Piere Duviols and Cesar Itier. Archivo Historia Andina, no. 17 (Cusco: Centro de Estudios Regionales Andinos "Bartolomé de las Casas," 1993).
4. Scholars of the history of textiles underscore the importance of the use of heddles as integral to the invention of a true loom, because heddles are an indicator of advanced, repeatable sequencing of the weaving process. In the development of weaving processes, these components—reed and heddle—became part of the loom itself, but not so in the Andes.
5. Penny Dransart, "Mysteries of the Cloaked Body," in *The Nature and Culture of the Human Body: Lampeter Multidisciplinary Essays*, ed. P. Mitchell, 161–87. Trivium 37 (Lampeter: University of Wales, 2007, 174).
6. These cloths became known as the Paracas textiles. See Julio C. Tello, *Paracas, primera parte* (New York: Institute of Andean Research, 1959); Julio C. Tello and Torbido Mejía Xespe, *Paracas, segunda parte: Cavernas y necropolis* (Lima: Universidad Nacional Mayor de San Marcos, 1979).
7. Other textile scholars of the period intrigued by Andean textiles were Lila O'Neale, Rebecca Carrion Cachot, Joy Mahler, Alan Sawyer, M. D. C. Crawford, and Philip Means.
8. Raoul d'Harcourt, *Textiles of Ancient Peru and Their Techniques*, ed. Grace G. Denney and Carolyn M. Osborne, trans. Sadie Brown (Seattle: University of Washington Press, 1962), 3. The sequence of publications is: Raoul d'Harcourt and Marguerite d'Harcourt, *Les tissus indiens du vieux Pérou* (Paris: A. Morancé, 1924); Raoul d'Harcourt, *Les textiles anciens du Pérou et leurs techniques* (Paris: Les Editions d'art et d'histoire, 1934), followed by the English translation in 1962. D'Harcourt published additional works on Andean textiles and music.
9. Selected publications on Andean textiles by Junius Bird include: Junius Bird and Joy Mahler, *America's Oldest Cotton Fabrics: A Report on Textiles Made in Peru Prior to the Domestication of South American Cameloids* (New York: Doric, 1951); Wendell Bennett and Junius Bird, *Andean Culture History* (New York: American Museum of Natural History, 1960); Junius Bird, "Technology and Art in Peruvian Textiles," in *Technique and Personality*, ed. Margaret Mead, Junius Bird, and Hans Himmelheber (New York: Museum of Primitive Art, 1963); Junius Bird and Louisa Bellinger, *Paracas Fabrics and Nazca Needlework: Third Century B.C.–Third Century A.D., Catalogue Raisonné* (Washington, D.C.: National, 1954); Junius Bird, John Hyslop, and Milica Dimitrijevic Skinner, *The Preceramic Excavations at the Huaca Prieta, Chicama Valley, Peru* (New York: American Museum of Natural History, 1985).
10. Sheila Hicks, e-mail communication with the author, March 3, 2013.
11. Sheila Hicks, e-mail communication with the author, March 4, 2013.
12. See for example, Arthur Danto, Joan Simon, and Nina Stritzler-Levine, *Sheila Hicks: Weaving as Metaphor* (New York: Bard Graduate Center, 2006). This is the catalog of the exhibition held at the Bard Graduate Center for the Study of Decorative Arts, New York, July 12–October 15, 2006.
13. John Cohen, *Past Present Peru*, vol. 2 (Göttingen: Steidl, 2010), 6.
14. Some of these questionnaires and other correspondence between Cohen and Bird are included in Cohen (see note 13, above).
15. Cohen's films include: *Q'eros: The Shape of Survival* (1979, 53 minutes); *Peruvian Weaving: A Continuous Warp for 5,000 Years* (1980, 25 minutes); *Mountain Music of Peru* (1984, 60 minutes); *Carnival in Q'eros* (1991, 32 minutes); *Dancing with the Inca* (1992, 58 minutes). A compendium of his photographs, including CDs of his films and music recordings from Peru was published as Cohen (see note 13, above).
16. A transcript of an oral history of James Bassler, recorded in 2002, is housed in the Archives of American Art: http://www.aaa.si.edu/collections/interviews/oral-history-interview-james-bassler-11858.

Selected Bibliography

Bergh, Susan
2013 *Wari: Lords of the Ancient Andes*. London: Thames and Hudson.

Bird, Junius
1963 "Technology and Art in Peruvian Textiles." In *Technique and Personality*, edited by Margaret Mead, Junius Bird, and Hans Himmelheber, 45–77. The Museum of Primitive Art Lecture Series, no. 3. New York: Museum of Primitive Art.
1979 "Fibers and Spinning Procedure in the Andean Area." In *The Junius B. Bird Pre-Columbian Textile Conference May 1973*, edited by Ann Rowe, Elizabeth Benson, and Anne-Louise Schaffer, 13–17. Washington, D.C.: The Textile Museum and Dumbarton Oaks.

Bird, Junius, and Milica Dimitrijevic Skinner
1974 "The Technical Features of a Middle Horizon Shirt from Peru." *Textile Museum Journal* 4, no. 1: 5–13.

Brunello, Franco
1973 *The Art of Dyeing in the History of Mankind*. Venice: Neri Poza.

Cahlander, Adele, and Suzanne Baizerman
1985 *Double Woven Treasures from Old Peru*. Saint Paul: Dos Tejedoras.

Cardon, Dominique
2007 *Natural Dyes: Sources, Traditions, Technology and Science*. London: Archetype.

Cohen, John
2010 *Past Present Peru: Andean Textiles*. Göttingen: Steidl.

Danto, Arthur C., Joan Simon, and Nina Strizler-Levine, eds.
2006 *Sheila Hicks: Weaving as Metaphor*. Bard Graduate Center for Studies in the Decorative Arts, Design and Culture, New York. New Haven: Yale University Press.

Donkin, R. A.
1977 "Spanish Red: An Ethnogeographical Study of Cochineal and the Opuntia Cactus." *Transactions of the American Philosophical Society* 67, part 5. Philadelphia: American Philosophical Society.

Emery, Irene
1966 *The Primary Structure of Fabrics*. Washington, D.C.: The Textile Museum.

Franquemont, Chris
1984 "Chinchero Pallys: An Ethnic Code." In *The Junius B. Bird Conference on Andean Textiles, April 7th–8th, 1984*, edited by Anne Rowe, 331–37. Washington, D.C.: The Textile Museum.

Gayton, Anna
1961 "The Cultural Significance of Peruvian Textile: Production, Function and Aesthetics." *Kroeber Anthropological Society Papers*, no. 25: 111–28.

Harcourt, Raoul d'
1987 *Textiles of Ancient Peru and Their Techniques*. Edited by Grace Denny and Carolyn Osborne. Seattle: University of Washington Press.

King, Mary Elizabeth
1976 *Analytical Methods and Prehistoric Textiles*. American Antiquity 43, no. 1: 89–96.

Murra, John
1962 "Cloth and Its Function in the Inca State." *American Anthropologist* 64, no. 4: 710–28.

Phipps, Elena

2010 *Cochineal Red: The Art History of a Color*. New York: Metropolitan Museum of Art; New Haven: Yale University Press.

2011 *Looking at Textiles: A Guide to Technical Terms*. Los Angeles: J. Paul Getty Museum.

Rowe, Ann

1977 *Warp Pattern Weaves of the Andes*. Washington, D.C.: The Textile Museum.

1978 "Technical Features of Inca Tapestry Tunics." *Textile Museum Journal* 17: 5–28.

1984 *Costumes and Featherwork of the Lords of Chimor: Textiles from Peru's North Coast*. Washington, D.C.: The Textile Museum.

Rowe, John Howland

1979 "Standardization in Inca Tapestry Tunics." In *The Junius B. Bird Pre-Columbian Textile Conference May 1973*, edited by Ann Rowe, Elizabeth Benson, and Anne-Louise Schaffer, 239–69. Washington, D.C.: The Textile Museum and Dumbarton Oaks.

Wallace, Dwight

1979 "The Process of Weaving Development on the Peruvian Coast." In *The Junius B. Bird Pre-Columbian Textile Conference May 1973*, edited by Ann Rowe, Elizabeth Benson, and Anne-Louise Schaffer, 27–50. Washington, D.C.: The Textile Museum and Dumbarton Oaks.

Young-Sánchez, Margaret

2004 *Tiwanaku: Ancestors of the Inca*. Lincoln: Denver Art Museum and University of Nebraska Press.

Zorn, Elayne

1979 "Warping and Weaving on a Four Stake Ground Loom in the Lake Titicaca Basin Community of Taquile, Peru." In *Irene Emery Roundtable on Museum Textiles 1977 Proceedings: Looms and their Products*, edited by Irene Emery and Patricia Fiske, 212–27 Washington, D.C.: The Textile Museum.

About the Artists

JAMES BASSLER

Born

Santa Monica, CA, 1933

Lives and Works

Palm Springs, CA

Education

1963 Bachelor of Arts, University of California, Los Angeles

1968 Master of Arts, University of California, Los Angeles

Selected Exhibition History

1976 *The Dyer's Art*, Museum of Contemporary Crafts, New York, NY

1978 *Erlebt bedacht gestaltst, Handwerkspflege, Bayern*, Munich, Germany

1983 *Wedge Weaves*, Elements Gallery, New York, NY (solo exhibition)

1986 *Craft Today/Poetry of the Physical*, American Craft Museum, New York, NY

1988 *Frontiers in Fiber/The Americans*, North Dakota Museum of Art, Grand Forks (toured venues in Asia through the U.S.I.A. Arts American Program)

1990 *Heads, Threads, and Treads*, Santa Barbara Museum of Art, CA

1995 *James Bassler*, United States Embassy, Warsaw, Poland (solo exhibition)

1996 *Ière Biennale du Lin en Haute Normandie*, Rouen and Paris, France (international invitational, traveling exhibition)

1999 *Small Works*, Long House Reserve, East Hampton, NY

2004–2006 Jane Sauer Gallery, Santa Fe, NM (solo exhibitions)

2010 Craft in America Center, Los Angeles, CA

2011 *Golden State of Craft: California 1960–1985*, Craft and Folk Art Museum, Los Angeles, CA

Collections

American Craft Museum, New York, NY

Art Institute of Chicago, IL

Cleveland Museum of Art, OH

Cotsen American Masters Textile Collection, Los Angeles, CA

Craft in America Study Center, Los Angeles, CA

Long House Reserve, East Hampton, NY

Minneapolis Museum of Arts, MN

North Dakota Museum of Art, Grand Forks, ND

Oakland Museum of Art, CA

JOHN COHEN

Born
New York, NY, 1932

Lives and Works
Putnam Valley, NY

Education
1955 Bachelor of Fine Arts, Yale University, New Haven, CT
1957 Master of Fine Arts, Yale University, New Haven, CT

Selected Exhibition History
1970 Rhode Island School of Design Museum, Providence (solo exhibition)
1977 Neuberger Museum, SUNY Purchase, NY (solo exhibition)
1980 Photographers Gallery, Wales (solo exhibition)
1992 Nacional Museo de Arte, Lima, Peru (solo exhibition)
1995 *Beat Culture and the New America, 1950–1965*, Whitney Museum of American Art, New York, NY
1997 *Keeping Time: The Music Photographs of John Cohen & Milt Hinton*, Corcoran Gallery of Art, Washington, D.C.
2001 *Recent Acquisitions: A Decade of Collecting*, The Metropolitan Museum of Art, New York, NY
2000 Peru: *A Parable of Images*, Moving Walls 4, Soros Foundation, New York, NY, and Washington, D.C.
2002–2006 *There Is No Eye* (solo traveling exhibition), Photographic Resource Center, Boston, MA; Chicago Cultural Center, IL; Santa Fe College, NM; Witherspoon Museum, Greensboro, NC; and seven other venues
2004 *Bob Dylan's American Journey*, Experience Music Project, Seattle, WA

Collections
Brooklyn Museum, NY
Corcoran Gallery of Art, Washington, D.C.
The Metropolitan Museum of Art, New York, NY
The Museum of Modern Art, New York, NY
National Portrait Gallery, Washington, D.C.
Neuberger Museum of Art, Purchase, NY
New York Public Library, NY
Rhode Island School of Design, Providence
Side Gallery, Newcastle, England
Victoria & Albert Museum, London, England

SHEILA HICKS

Born
Hastings, NE, 1934

Lives and Works
Paris, France, and New York, NY

Education
1957 Bachelor of Fine Arts, Yale University, New Haven, CT
1959 Master of Fine Arts, Yale University, New Haven, CT

Selected Exhibition History
1963–1964 *Woven Forms*, Museum of Contemporary Crafts, New York
Textiles by Sheila Hicks, The Art Institute of Chicago, IL
1967 3ème Biennale Internationale de la Tapisserie, Contonal Museum of Fine Arts, Lausanne, Switzerland.
1971 *Tapis Mural de Sheila Hicks*, Galerie National de Bab Rouach, Rabat, Morocco
1977 *Sheila Hicks*, Museum of Contemporary Art, Belgrade, Serbia
1982 *Newborn*, Gallery/Gallery, Kyoto, Japan
1987 *Textile, Texture, Texte*, Musée des Beaux Arts, Pau, France
1997 *History of a Doncho*, Kiru Municipal Cultural Center, Gumma, Japan
2006 *Sheila Hicks: Weaving As Metaphor*, The Bard Graduate Center for Studies in the Decorative Arts, Design, and Culture, New York (solo exhibition)
One of a Kind: The Studio Craft Movement, The Metropolitan Museum of Art, New York, NY
2008 *Looking Forward/Looking Back: Recent Acquisitions in 20th- and 21st-Century Design*, Cooper-Hewitt, National Design Museum, New York, NY
Tapisserie contemporaine et art textile en Europe, Académie des beaux-arts, Paris, France
2009 *elles@centrepompidou*, Centre Pompidou, Paris, France
Antoine Broccaro Pavilion of Art & Design, London, England
2010 *Everything Design*, Die Sammlungen des Museum für Gestaltung, Zurich, Switzerland
2010–2012 *Sheila Hicks: Fifty Years*, Addison Gallery of American Art, Andover, MA; ICA, Philadelphia, PA; Mint Museum, Charlotte, NC (solo traveling exhibition)
2012 *The Imminence of Poetics*, São Paulo 30th Biennale, São Paulo, Brazil

Collections
Art Institute of Chicago, IL
Centre Georges Pompidou, Paris, France
The Cleveland Museum, OH
The Metropolitan Museum of Art, New York, NY
The Minneapolis Institute of Art, MN
Musée des Arts Décoratifs, Paris, France
Museo de Bellas Artes, Santiago, Chile
The Museum of Decorative Arts, Prague, Czechoslovakia
The Museum of Fine Arts, Boston, MA
The Museum of Modern Art, New York, NY
The Museums of Modern Art, Tokyo and Kyoto, Japan
The Philadelphia Museum of Art, PA
The Saint Louis Art Museum, MO
The Smart Museum, Chicago, IL
Stedlijk Museum, Amsterdam, Netherlands

About the Author

Independent scholar and curator Elena Phipps received her doctorate from Columbia University in 1989. From 1977 to 2010, she was Senior Museum Conservator at the Metropolitan Museum of Art, New York, and in that position she co-curated *The Colonial Andes: Tapestries and Silverwork 1430–1830* and co-authored the accompanying catalog, which was the recipient of the Alfred Barr Jr. Award for best exhibition catalog (2004–2005) and the Mitchell Prize (2006).

Her recent publications include *Cochineal Red: The Art History of a Color* (Metropolitan Museum of Art and Yale University Press, 2010) and *Looking at Textiles: A Guide to Technical Terms* (J. Paul Getty Museum, 2011). She is a co-curator of the forthcoming exhibition *The Interwoven Globe: Textiles and Trade, Sixteenth–Eighteenth Centuries*, which will open at the Metropolitan Museum of Art in the fall of 2013. Phipps is also currently the president of the Textile Society of America, a national nonprofit professional organization dedicated to the dissemination of information and knowledge about textiles.

Fowler Museum at UCLA